Penns Grove and Carneys Point

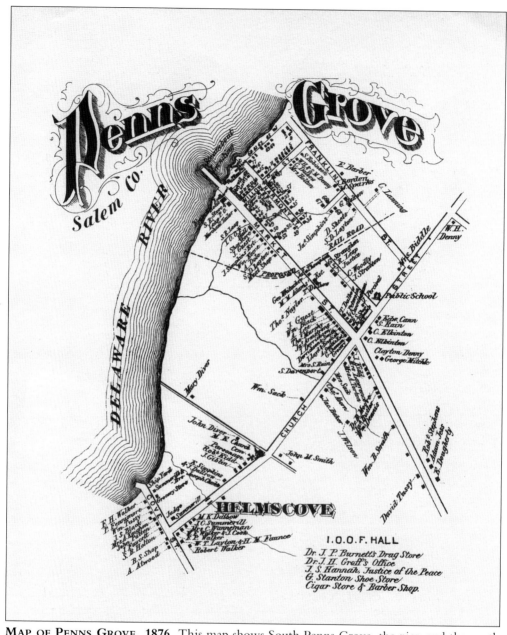

MAP OF PENNS GROVE, 1876. This map shows South Penns Grove, the pier, and the north end of town.

Penns Grove and Carneys Point

To Darlene-
Frank & Darlene-
my good friends!
Enjoy!

Donna Federanko-Stout
11/28/05

Donna Federanko-Stout
for the Historical Society of Penns Grove & Carneys Point

Published by Arcadia Publishing
Charleston SC, Chicago IL, Portsmouth NH, San Francisco CA

Printed in Great Britain

Library of Congress Catalog Card Number: 2005931668

For all general information contact Arcadia Publishing at:
Telephone 843-853-2070
Fax 843-853-0044
E-mail sales@arcadiapublishing.com
For customer service and orders:
Toll-Free 1-888-313-2665

Visit us on the internet at http://www.arcadiapublishing.com

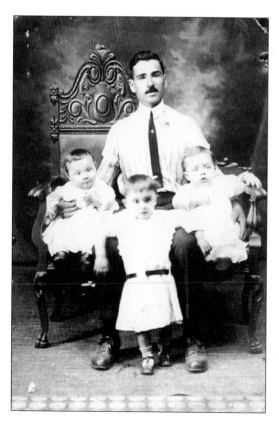

VINCENZO PELURA, 1919. The author's grandfather was only 17 when he came to America from his hometown in Terramo, Bellante, in the province of Abruzzi in Italy. With ingenuity, hard work, and determination, he fulfilled his dream of becoming an American businessman with a taxi service, a spaghetti house, a wife, Rose, and children, Frances, James Jr., Edith, Albert, Evelyn, and Darlene. Known to all by his American name, James Pelura Sr., or Jimmy, he had a reputation for honesty and charity that still follows him long after his passing in 1955.

CONTENTS

ACKNOWLEDGMENTS

I was 10 when I first heard W. W. Summerill speak. Engineer, writer, and historian, he hailed from one of Penns Grove's oldest families. I credit him for my love of our history. When he made a presentation at our Girl Scout meeting, I was captivated, drawn back to those good old days of which he spoke: lounging on the breezy verandas at French's Hotel, strolling under the shade of the grove, sailing down the river on the side-wheeler *Thomas Clyde*, and sipping sarsaparilla at the apothecary at Dog Town Corner. These became vivid scenes that fired my imagination. From that day on, our past became my passion, too, and I have been researching and writing about it ever since. It led to almost 30 years of writing stories for the local weekly, the *Sampler*, and the creation of my own publication, the *Hometown News*.

Since cofounding the Historical Society of Penns Grove and Carneys Point in 1999, I have been able to communicate my love of our history through slide shows, public meetings, exhibits, and historical events, such as Cove Day and Grove Day. My goal is to share the stories of our rich and colorful past, just as W. W. Summerill did.

In compiling the editorial content describing these postcards from the past, I relied on the writings of W. W. Summerill and historians George Cable and Dr. Henry Flanagan; Chushing and Sheppard's *History of Salem County*; Salem County Historical Society's periodicals *The Way It Used to Be* and *O the Great Days*, Millennium Edition, by Edward W. Humphreys; the *Penns Grove's 75th Anniversary Souvenir Edition*, published by the *Penns Grove Sun*; Sunbeam Publishing Company, Salem, featuring articles by Bill Lynch; the *Today's Sunbeam*, Sunbeam Publishing Company, Salem; *The Day the Town Burned*; and the Historical Society of Penns Grove and Carneys Point. The postcards and images used in this book are from my personal collection and that of the Historical Society of Penns Grove and Carneys Point. The society is grateful to those who have donated historical items. It is through the generosity of the society's over 500 members that this has been made possible.

Special thanks go to the following: the first lady of Penns Grove, Marlene Morris, who sparked my interest in postcards and whose mission is to collect and preserve facts, stories, and memorabilia; her husband, George Morris, a published expert on the prehistory of our area, whose archeological digs include the excavation at the French's Hotel site; Maryanne Brown-Mackay, who helped make the dream of a historical society a reality; Costas Burpulis and his lovely wife, Maria, who have shared photographs, stories, and memories; Olga Banco Stalcup for her knowledge of our history; my kindergarten teacher, Eleanor Clunn, who makes me smile when, after 40 years of teaching, she says I was always one of her brightest; mentor and friend Ellie Peak Zane, who shares my love of our history; my husband, Russell, and my children, Maggie, Sarah, and Rebecca, who have always supported me in my historical endeavors; my father, Donald, whose colorful stories always amuse me; my grandmother Rose and her wonderful stories, especially those about my grandfather James, whom I never had a chance to know; most of all, Rose and James's daughter Evelyn, my mother, who never discouraged, always encouraged, and who now tells the most wonderful stories herself.

I will never forget the time someone said to me, "Oh, you live too much in the past," and to that remark, I heartily replied, "Thanks!"

INTRODUCTION

Centuries before settlers reached the shores of southwestern New Jersey, the mighty Delaware River fed the native Lenni-Lenape Indians camping along its banks. They thrived on their catch from the big, rushing river and on the game they hunted in the forests nearby. In the 1630s, Swedes came to the cove to farm the uplands and trap furbearing animals in the marshes. In 1675, William Penn of Philadelphia held deed to this land, which later came to be known as Upper and Lower Penn's Neck. In 1731, southern parcels of the land were purchased by Irish immigrant Thomas Carney. During Colonial times, the shores stood watch over the new colonies, guarding against the threats of the British. Legend has it that a naval battle was fought in the Delaware and a cannonball fired from the British frigate HMS *Roebuck* hit the wall of the tavern at Helm's Cove.

In the early 19th century, Upper Penn's Neck was divided into smaller hamlets: Oldmans to the north, the area consisting of a pier and boat landing below that became known as Penns Grove; and the cove to the south became known as South Penns Grove. The land surrounding Penns Grove was later named Carneys Point for landholder Thomas Carney. With shad and sturgeon plentiful in the river, the fishing industry, the boatyards, and the shipping piers grew. Penns Grove prospered. Harry Dalbow, whose family operated a cannery, perfected a vacuum canning process for the sturgeon roe and packaged it under the name Romanoff Caviar. Thus, by the late 1880s, Penns Grove had become "the Caviar Capital of the World."

In the early 20th century, tourism flourished as well. Travelers from Philadelphia and points north and south rode the river by steamer or ferry and flocked to the banks of the Delaware to enjoy sparkling beaches, cool breezes, and shady riverside groves. Penns Grove and Carneys Point had become a destination.

Visitors and townsfolk alike shared their thoughts on delightful postcards. Featuring images of French's Hotel, the relaxing groves, trolley cars, ferryboats, stately churches, streetscapes, and common scenes from a quiet river town, these cards made their way across the country. Expressive phrases of the day were used on the backs of these penny postcards. A penny for your thoughts, such as a French's Grove card, signed Maize and dated August 1906: "Don't you think this is a good postcard of the grove? I am having a fine time!" On another one, from July 1905, Bertha Coyle happily proclaims, "We are Summering in Penns Grove!"

The foot of West Main Street in Penns Grove was an exciting place, with the bustle of activity at the pier, as well as special events like parades, traveling circuses, and sharply dressed soldiers performing military drills. The Home Coming and Civic Gala Day celebration, in 1908, brought thousands to town to participate in the events of the day. Orator and statesman William Jennings Bryant visited while whistle-stopping up and down the East Coast. Wild West show sharpshooter Annie Oakley arrived for sportsmanship competitions, hosted by longtime friend and businessman R. F. Willis. Famed composer John Philip Sousa held rousing band concerts in the grove at French's Hotel. Vaudeville and movie star W. C. Fields visited his sister's home on Delaware Avenue—when all the shades were drawn, folks knew he was in town. It is said that during the Roaring Twenties, notorious gangster Al Capone made frequent visits to the shadier side of the waterfront.

World War I and the expansion of the DuPont Works in Carneys Point signaled the start of the industrial boom, one that changed the area forever. Tourism waned as competition grew from other riverside and seaside attractions. The fishing trade also slackened, as the river felt the negative effects of refineries and factories along its banks. By the 1920s, fishing as an industry on the Delaware River was doomed. Yet Penns Grove and Carneys Point boomed, growing quickly to accommodate the influx of workers from across the country and across the ocean. The DuPont plants provided jobs around the clock, and the shift worker was born. The need for housing was so great that not a single bed went cold. When a day worker left for his job at 7:00 a.m., a night worker would take his bed until it was time for his shift.

Emigrants hailing from Italy, Poland, Russia, Ireland, and Greece came with their families, seeking employment. Some went to the factories or the railroad, and others became merchants, taking advantage of the abundant business opportunities in the growing community. Many plied their trades as carpenters and masons, building new homes in the old-world style. The land of opportunity was here, with its river, railroad, factories, towns, and farms that provided the means of making a good living.

Carneys Point, once predominantly farmland, was now nicknamed "the Village," as new quarters were quickly being built to house the growing number of DuPont employees and their families. Temporary barracks in the ruberoid villages were filled with families speaking a variety of native tongues but having the same agenda: making a life in this new land. Larger executive homes were constructed for supervisors and managers of DuPont. The population soared, and the riverside resorts became the new hometowns for thousands. Today generations of those families still remain.

Among notable persons who called the area home are actors John Forsythe and Bruce Willis, Olympic medalist Don Bragg, and a significant number of judges, politicians, and groundbreaking scientists.

Through the mid-1960s, postcards could still be found in Penns Grove at the News Agency on Broad and Main Streets, old Dog Town Corner. Postcards from the past remind us of every refreshing river breeze, every whistle of an arriving ferry, every beautiful sunset, and every lazy summer's day in the words written by those who visited over 100 years ago.

Plans are now under way to turn the clock back more than 100 years at the foot of West Main Street in old French's Grove in Penns Grove. The developers of the proposed Riverwalk at Penns Grove have a vision for this waterfront property that combines the charm of the borough's past with the smart shops, fine restaurants, and special events of today. With plans for opening in the summer of 2006, there is hope for the return of postcard greetings from Penns Grove.

One

GREETINGS FROM PENNS GROVE

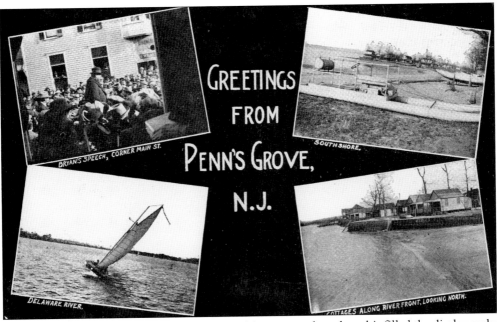

GREETINGS FROM PENNS GROVE, 1908. Inviting postcards such as this filled the display racks of drugstores, the newsstand, and the lobby at French's Hotel. Featuring enticing pictures of the waterfront, town scenes, and architecture, these postcards from Penns Grove found their way across the country, sent from this tiny riverside town in the early 20th century.

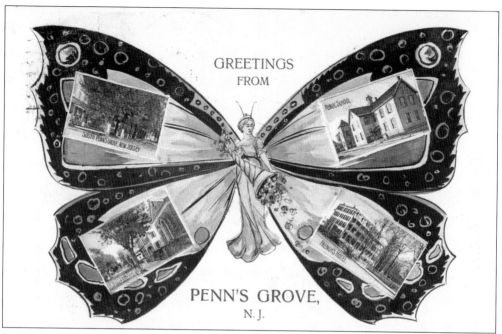

LOVELY LADYLIKE GREETINGS, 1908. A striking artist's rendition of a lovely lady welcoming visitors to Penns Grove graces this period postcard. Photographic images of the old Cove Store, tree-lined Main Street, stately French's Hotel, and the old wooden school are imposed on the wings of this beautiful creature.

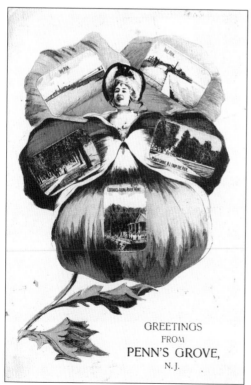

BEAUTIFUL BLOSSOMS BECKONING VISITORS, 1908. "Do you think she looks like me?" is the question young Mary asks on this postcard dated 1908. Delightful summer cottages, shaded French's Grove, and the River Pier provide some of the diversions that could be found.

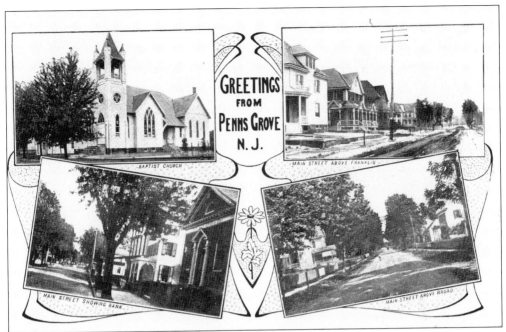

TRANQUIL SCENES OF SMALL-TOWN LIFE, 1905. This greeting offers the enjoyment of the simple life and the quiet comforts available in a visit to Penns Grove in a collage of family values: God, country, and family.

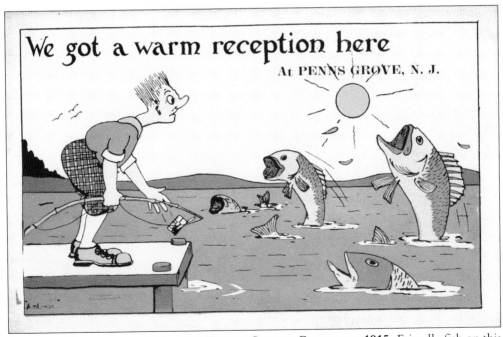

CARTOON SKETCHES, A POPULAR WAY TO SEND A GREETING, 1915. Friendly fish on this comical card jokingly speak to the folks back home of the kind of welcome that was extended to guests summering in Penns Grove.

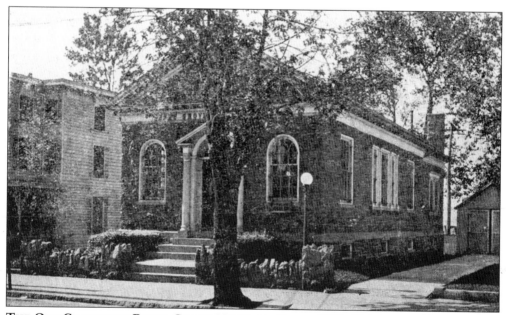

SOUVENIR FOLDER

M_____

POSTCARD PORTFOLIOS, A CHARMING KEEPSAKE, 1920. Souvenir portfolios, or folders, were a popular way for tourists to remember their visit to Penns Grove. There were several versions of the photographic keepsakes. The souvenir folders usually contained a series of 10 scenes from around town that could be easily admired and then neatly tucked away in a protective cardboard cover. All of the remaining postcards in this chapter (through page 24) are souvenir folder cards.

THE OLD GRAYSTONE PENNS GROVE NATIONAL BANK, 1920. This image of Penns Grove's oldest bank was prominently displayed as the first photograph in one of the versions of Penns Grove's souvenir portfolios.

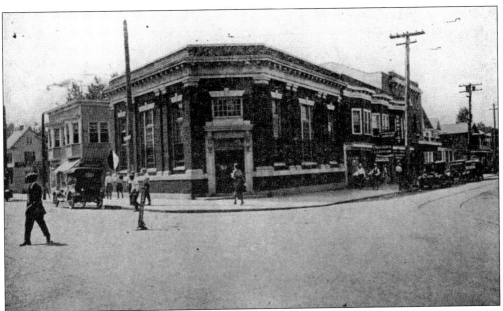

THE COLONIAL REVIVAL PEOPLE'S BANK. The Colonial Revival–style of the *c.* 1917 People's Bank building secured its place as a dominant piece of architecture on the corner of Broad and Main Streets. Having laid dormant for nearly 30 years, the sleeping giant was awakened in 2005, and work was under way to restore this building to its former place as an anchor in the center of Penns Grove.

STREET SCENE, SOUTH BROAD. This image of the tree-lined main thoroughfare promotes the image of small-town America with its beautiful old homes and friendly streets. The trolley tracks can be seen at the right of the photo.

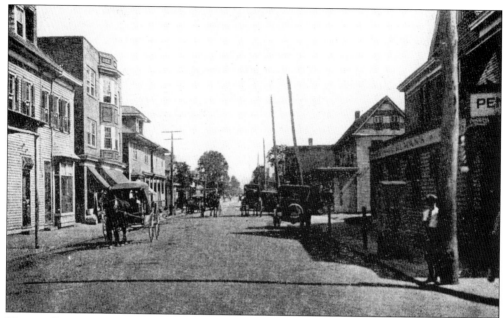

NORTH BROAD AT THE CENTER OF TOWN, C. 1910. This image of Broad Street looking north shows the early businesses that operated downtown. Also featured is a delightful mix of transportation such as the horse and carriage on the left and the horseless carriage on the right. The buildings to the left still remain standing and in use today.

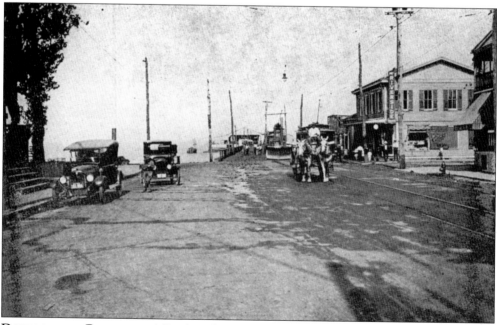

DOWN BY THE RIVERSIDE. Mixed modes of transportation are also apparent in this image of the busy foot of Main Street at the pier in Penns Grove. The buildings to the right were built around 1840 by Charles Elkinton, who operated several businesses, including a restaurant, livery stable, and the Riverside silent movie theater.

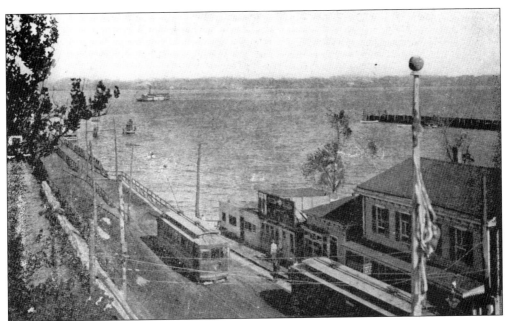

WAITING FOR PASSENGERS AT THE PIER. Trolleys line the pier at Penns Grove, preparing to take on passengers from the steamers that plied the Delaware. Tickets for the trip by trolley could be purchased at the pier in the trolley car waiting room located next to Elkinton's Riverside Cafe seen on the right.

THE DUPONT PLANT NO. 1 ON THE CARNEY PLANTATION. Gazing across the shoreline of the Delaware at Penns Grove, travelers could get a glimpse of DuPont Plant No. 1 on the former site of the Carney Plantation in Carneys Point.

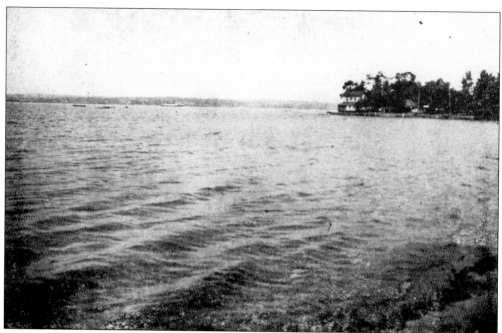

A View from the Pier. Passengers could take a look north at the mighty Delaware River before boarding the steamer or ferry on the return trip home.

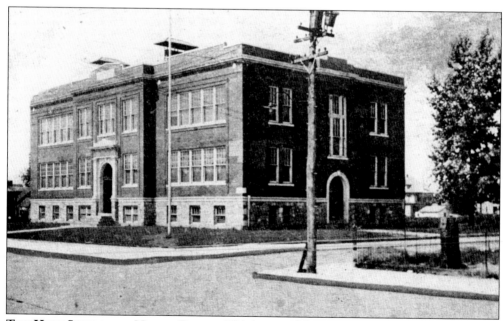

The High School on North Broad. This image of the Penns Grove High School, built in 1914, is the first card featured in another of the souvenir portfolios. As the town grew, students and teachers outgrew their quarters in the old wooden school on the northwest corner of North Broad Street. Preparations were made for this modern brick structure to be built across Harmony Street and become home to the growing number of high school students.

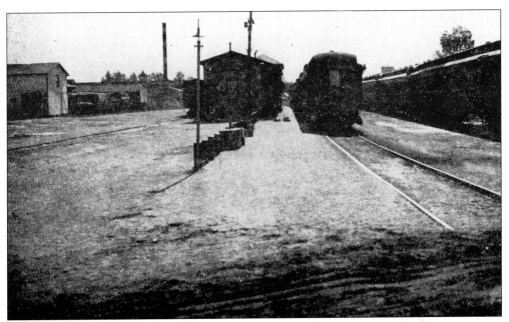

ALL ABOARD AT THE PENNS GROVE RAIL STATION. Travelers and workers came to Penns Grove by rail as well as by boat. Regular train schedules provided convenience and a safe trip. The bustling rail yard also hosted work trains for the DuPont plants and an alternative to shipping products by truck or boat.

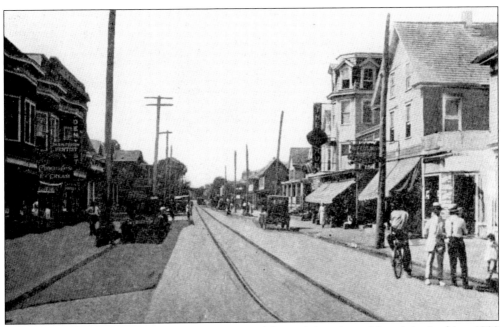

BUSY BROAD STREET, LOOKING SOUTH. Broad Street is buzzing with activity in this *c.* 1920 image. Trolley tracks run down the center of Broad Street, and new merchants cropped up on both sides of the street, with the Broad Theatre on the left and Rudinoff's Penns Grove Variety Store and the Hub, along with several other businesses, on the right.

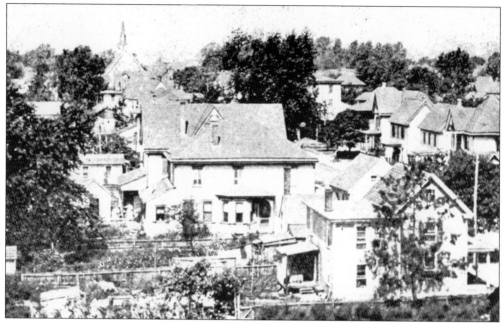

A Bird's-Eye View of Town. A popular style of postcards featured in the early 20th century was the "bird's-eye view." This new method was obtained by climbing atop the roof and taking an aerial panoramic view of town, giving the viewer a different perspective. Rows and rows of typical Americana homes in Penns Grove can be seen here.

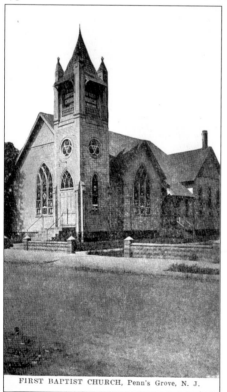

FIRST BAPTIST CHURCH, Penn's Grove, N. J.

The First Baptist on State Street. Churches were often included in the souvenir portfolios, expressing the wholesomeness of small-town life in Penns Grove. Some of the striking architectural features of the frame 1907 First Baptist Church include the gabled bell tower and the ornate stained glass windows.

EMMANUEL METHODIST AT CHURCH AND SOUTH BROAD STREETS. Another beautiful church showcased in the souvenir folders was Emmanuel Methodist, constructed in 1846. Emmanuel's sturdy Gothic style matched the fortitude of some of Penns Grove's oldest families, whose monuments are located in the cemetery next to the church.

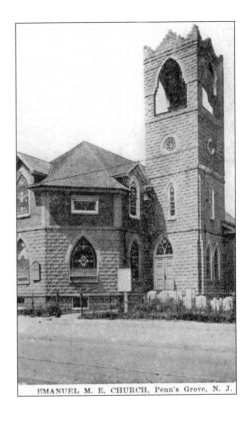

EMANUEL M. E. CHURCH, Penn's Grove, N. J.

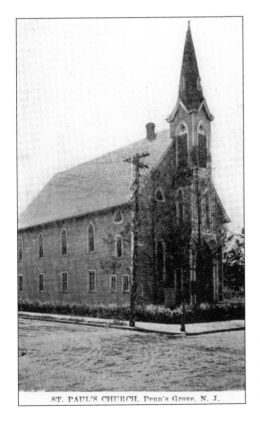

ST. PAUL'S CHURCH, Penn's Grove, N. J.

ST. PAUL'S METHODIST ON FRANKLIN STREET. The tall, thin bell tower of the noble St. Paul's Methodist Church, built around 1885, was nestled in the quiet residential area of Penns Grove at the corner of Franklin and Harmony Streets.

19

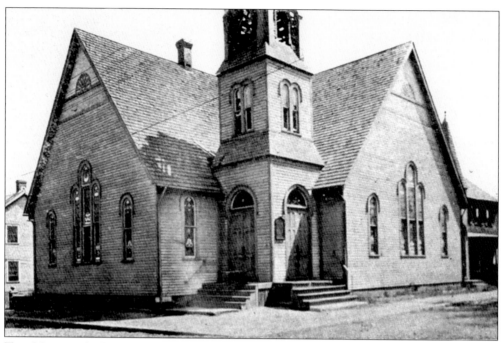

The Mariner's Church near the River. Established in 1860 by Joseph Guest, the Bethel Methodist Protestant Church often went by the simpler name of the Mariner's Church. Guest felt that a church nearer to the river would help serve the needs of the many fishermen and boatmen of the community.

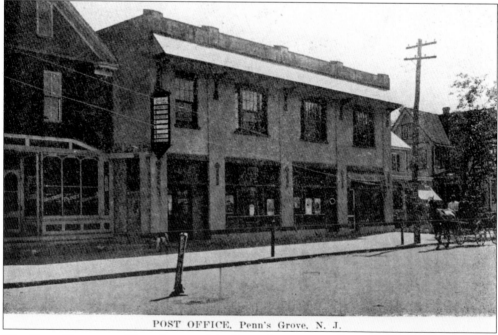

POST OFFICE, Penn's Grove, N. J.

The Post Office on Main Street. The Penns Grove Post Office was moved to this modern facility on East Main Street near Broad Street, as seen in this *c.* 1915 image. This photograph is featured first in another of the souvenir folders.

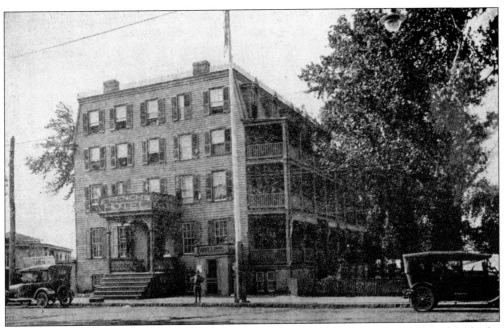

THE GRAND OLD FRENCH'S HOTEL. French's Hotel was the grand lady who sat beside the river at the foot of West Main Street near the pier in Penns Grove. It was the first stop for the many who traveled to Penns Grove to enjoy summer on the Delaware shore.

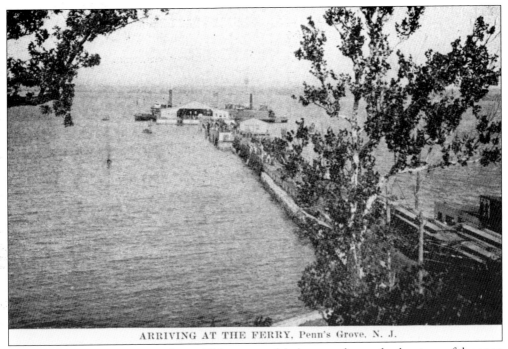

ARRIVING AT THE FERRY, Penn's Grove, N. J.

A BIRD'S-EYE VIEW OF THE PIER. This resourceful photographer took advantage of the open verandas of the French's Hotel to take a bird's-eye view of the pier at Penns Grove. The view was slightly obstructed by the branches of the shade trees of French's Grove.

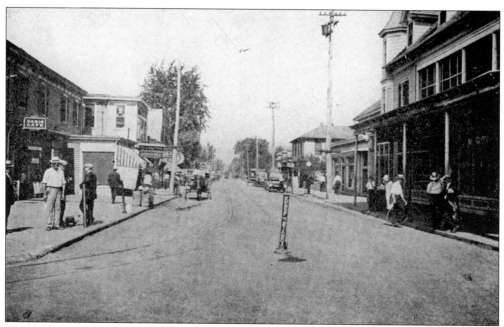

MERCHANTS ON MAIN STREET. In 1910, Penns Grove was growing and so was its selection of merchants. The Paris Café is seen on the left, an apothecary on the right with Cunningham's livery and a blacksmith shop next door.

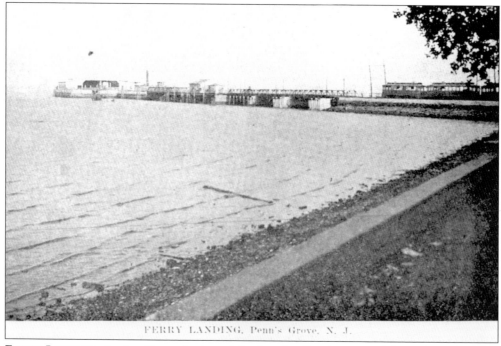

FERRY LANDING, Penn's Grove, N. J.

FERRY LANDING AT THE PIER. A view of the ferry landing is captured from along the shore at French's Grove. The trolleys await disembarking passengers at the foot of the pier.

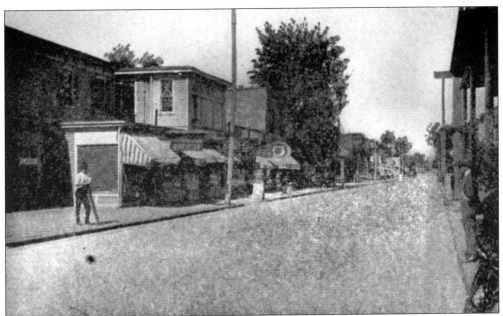

MORE SHOPPES ON MAIN. Gentle breezes softly rustle the canopies of these little shops to the left, situated on West Main Street near the Broad and Main corner.

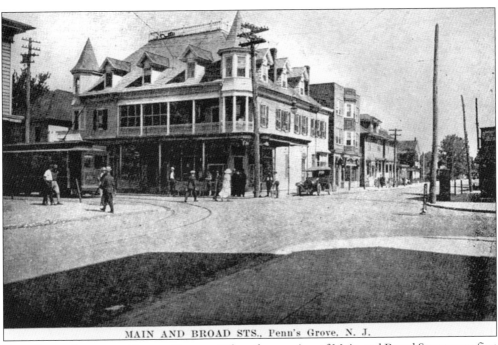

MAIN AND BROAD STS., Penn's Grove, N. J.

THE CROSS ROADS IN PENNS GROVE. When the crossing of Main and Broad Streets was first laid out, it was referred to as the Cross Roads. Around 1910, it was dubbed Dog Town Corner. Later the more polite name of Union Corner was given to this intersection in busy downtown Penns Grove.

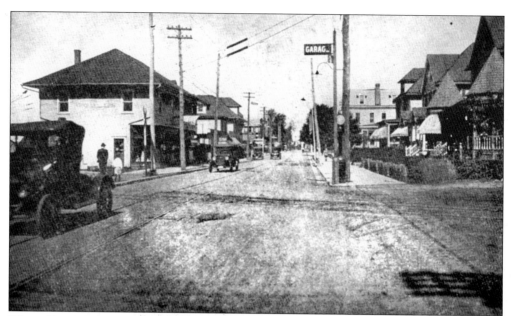

WEST MAIN STREET AT FRANKLIN STREET. Businesses and small factories sprouted up on West Main Street heading toward the pier. These commercial enterprises, on the left, shared West Main with large Victorian homes, on the right, occupied by some of Penns Grove's most influential people.

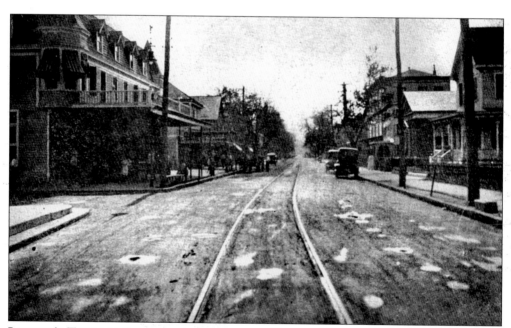

LAYTON'S TOBACCO SHOP ON THE SUMMERILL BLOCK. This *c.* 1920 view features Layton's Tobacco Shop on the Summerill block at the corner of Penn Street, on the left, and West Main Street. The stores on the left also include a barber shop, an ice cream parlor, and the offices of the *Penns Grove Record* newspaper owned by the Summerill family.

Two

THE COVE
AND THE GROVES

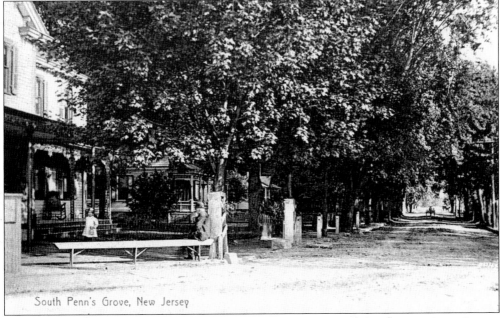

South Penn's Grove, New Jersey

THE COVE AND SOUTH PENNS GROVE, 1905. This is the place where Penns Grove began. Before the arrival of the Europeans, it served as a campsite for the native Lenni-Lenape tribe along the Delaware. Swedes settling in the area in the 1630s referred to the area as the "Boute." John Fenwick and William Penn later held title to the land. In the 1880s, it was a small village of shopkeepers, fishermen, canners, and close-knit families that became officially known as South Penns Grove. The Summerill Brothers' Cove Store, a general store that also carried sound lumber, decorative roofing shingles and other quality architectural elements, is pictured on the left in this 1905 postcard. With the booming fishing industry along the Delaware in the late 19th century, they became well-known for their fine imported net twine, marketed under the name "Summerill's Golden Irish Thread." As well as operating a store and shipping business, the Summerill family was responsible for building a number of beautiful residences along Maple Avenue in the 1880s and 1890s.

HELM'S COVE AND HELM'S TAVERN. When Andrew Helm took possession of the land around 1750, it came to be known as Helm's Cove, a name that it still carries today. Helm's holdings included 250 acres around the cove. Evidence points to the fact that Helm built this brick house on East Maple Avenue. In March 1771, he and his wife, Catherine, applied for a license to keep a tavern and a ferry. Helm's Tavern continued in the family under various names, Walker's Tavern and Diver's Tavern, up until the 1880s. It was then that Catherine's sons, being converted at a Methodist revival at the old Cove School, no longer wished to serve the "demon" alcohol. The next morning, the converts gathered at the tavern's sign, along with the revival minister and fellow believers, chopping down the sign "so it would never sprout again!"

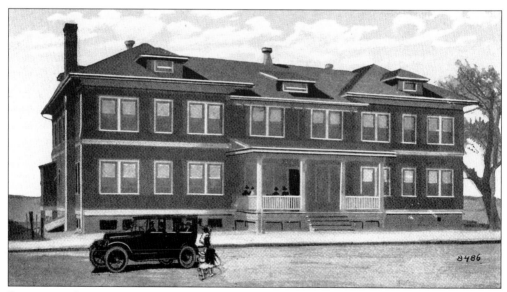

RIVERSIDE APARTMENTS AT HELM'S COVE. Built along the shore at Helm's Cove in 1910 by the DuPont Company to serve as an apartment house for their unmarried men, especially supervisors and chemists, this craftsman-style building with its linear design and shed dormers has not changed that much through the years. Additional balconies and porches have been added, affording a beautiful view of the Delaware River and its stunning sunsets. Lumber being brought by schooner from the south during the summer would be unloaded at the small wharf once located on this property, part of the Summerill property in the 1880s.

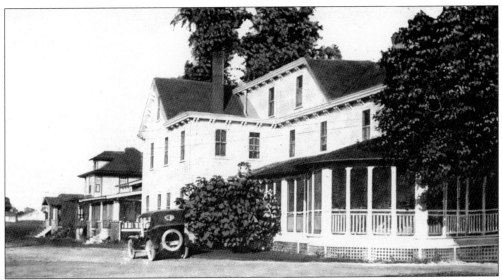

OLD RIVERSIDE CLUB HOUSE, FORMERLY THE SUMMERILL COVE STORE, 1920. When the DuPont Company expanded around 1915, it came into possession of the old Summerill Cove Store. The Cove Store had served residents of the village since its opening in 1819 by original owner, James Sherron. The Summerills operated their family business there for over 80 years. Prominent members of the Summerill family included a senator, judge, newspaper editor, and local historian, W. W. Summerill. The 1819 building was converted for DuPont Company use and renamed the Old Riverside Club House.

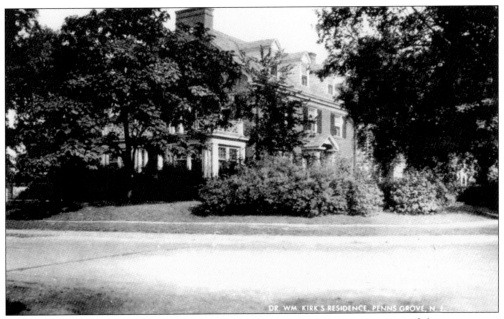

THE RESIDENCE OF DR. WILLIAM KIRK, 1930. After the construction of the new, more modern DuPont Clubhouse was built along the river, the Old Riverside Club House, which once served the community as the Cove Store, was demolished. Erected in its place was this amazing *c.* 1925 Colonial Revival brick home, which became the residence of DuPont Company plant manager Dr. William Kirk.

FRENCH'S GROVE ALONG THE BANKS OF THE DELAWARE, 1905. It was the time of parasols, straw hats, and Sunday afternoon strolls under the shade of the towering trees in French's Grove along the banks of the Delaware River. French's Grove was one of the only recreation areas of its period on the eastern shore of the Delaware from Camden to Cape May. Patrons to the grove were primarily wealthy people from Philadelphia, Wilmington, and other surrounding areas, who arrived by steamer to this relaxing destination.

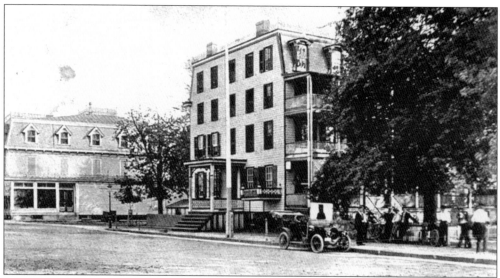

FRENCH'S HOTEL ON THE DELAWARE, 1905. Original construction of the grand French's Hotel began in 1850. Local businessmen by the names of Leap and Elkinton were involved, and before completion, the hotel came under the management of Joseph G. French. French had become known for his hostelry skills in his running of a fine hotel in Woodstown and the smaller hotel that bore his name on the corner of Main Street and Delaware Avenue. In 1883, French's Hotel was described as "a well kept house, and it is well filled with boarders in the summer season." The original Leap family general store, established in the 1840s, is situated to the left of French's Hotel.

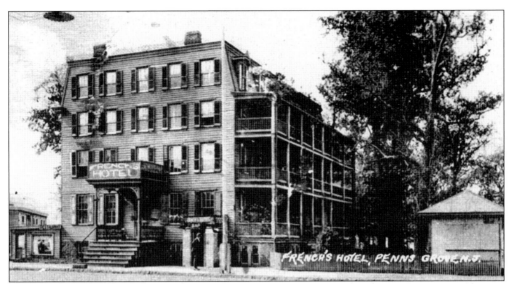

THE VERANDAS AT FRENCH'S HOTEL, 1905. This is a grand view of the riverside verandas of French's Hotel. These lovely open porches allowed hotel guests the benefit of the cool summer breezes off the Delaware. Originally built with three stories, a fourth was later added. A petite restaurant sat to the left of the hotel entrance. Townsfolk, hotel guests, and passengers awaiting the next steamship or ferry could treat themselves to a refreshment from the outdoor stand. Those more hearty could spend their waiting time in the barroom located in the basement of French's Hotel.

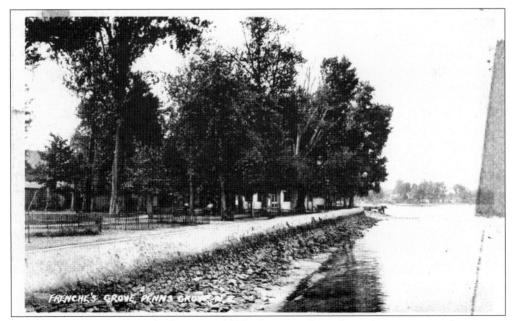

AMUSEMENTS IN FRENCH'S GROVES, 1905. On a number of occasions, renowned composer John Philip Sousa delighted audiences with his band concerts under the shade of French's Grove. Amusement rides of the day, traveling circuses, and camp meetings all took place in the grove. A pavilion and a rink for skating were also constructed there by Joseph French. A small building on the north end of the property was once home to a colorful carousel.

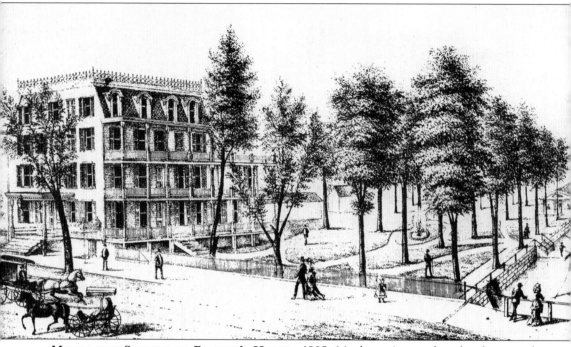

MYTHS AND STORIES OF FRENCH'S HOTEL, 1905. Much gossip was shared and many tales are contributed to the so-called "goings on" at the basement bar of the old hotel. One rumor told of a local businessman, a pillar in the church community, who had a tunnel constructed from his home to the basement bar in order not to be seen by the public. Other myths from the era of Prohibition state that the basement bar became a speakeasy, furnishing refreshment for out of town gangsters like Al Capone and his ladies. Willard Green once shared a story from his childhood about French's Hotel. Green said that as a very young boy, he was frightened of the basement bar at French's Hotel. To him, it was a dark place that smelled of beer and cigars, and as he recalled, at one time, he was nearly trampled by a tipsy patron as he rushed from the bar in fear of missing the ferry. What went on in the later years of French's Hotel was a somewhat sad story. With World War I raging in Europe came the industrial boom, and factories like the DuPont plant sprang up along the Delaware. Tourists became fewer, and the catch dwindled as the river became polluted. The decline of the tourist trade caused the decline of the great French's Hotel. Poor health forced Joseph French to retire. Some said that the addition of the fourth floor compromised the structure, and it fell into disrepair. The hotel was later sold, and the named changed to the Olympia Hotel, but its fate was sealed. No longer a resort town, the need for summer lodging dwindled. French's Hotel would serve its last guest in 1931. After standing vacant for two years, in 1933, the hotel was razed. Only the memories and myths of this grand structure remained.

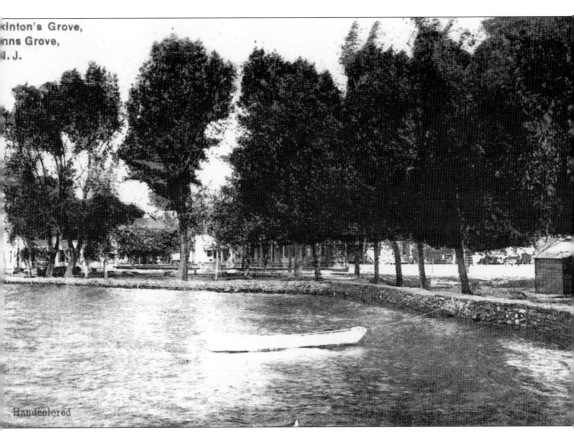

Handcolored

ELKINTON'S GROVE ON DELAWARE AVENUE, 1907. Even before visitors flocked to the shore at French's Grove, there was Elkinton's Grove. Prominent businessman Charles Elkinton was one of the first to provide a peaceful setting in which to enjoy a day out along the river in the 1840s. Elkinton's Grove was conveniently situated close to the pier at the foot of West Main Street, the pier being a part of Elkinton's enterprises. A picnic lunch or a day of boating could be had in this little cove surrounded by hearty shade trees. Along with constructing the pier, Elkinton also purchased the steamer, the *Osceola*, erected buildings at the foot of West Main Street, including the original French's Hotel, and maintained several businesses.

31

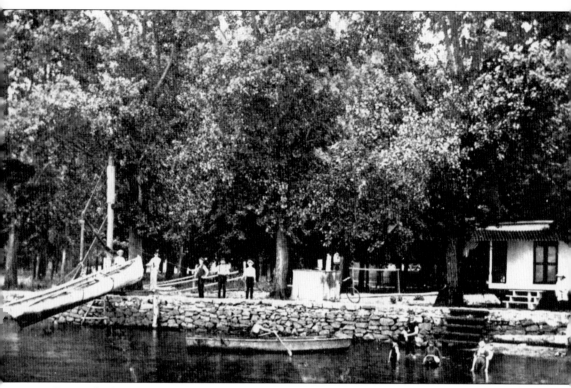

SHEBLE'S GROVE ON DELAWARE AVENUE, 1907. Seeing the trend of summer guests making trips to Penns Grove, Samuel Sheble would not be left out. Sheble purchased a quantity of land from S. R. Leap, a member of the prominent Leap family businessmen and landholders. Part of the parcels included the riverfront property just north of Elkinton's Grove. This stretch of land along the river became known as Sheble's Grove. Swimming, sunbathing, picnic lunches, and other summertime activities could be enjoyed there, along with boating and fishing. During the Spanish–American War in 1898, the grove was used for more serious matters. U.S. military troops made camp at Sheble's Grove on special assignment to guard the DuPont Powder Works, just down river in Carneys Point. The grove was also used as drill grounds to assist in the training and readiness of the troops. Marches were made from Sheble's Grove to the foot of West Main Street to the delight of gathering crowds of spectators.

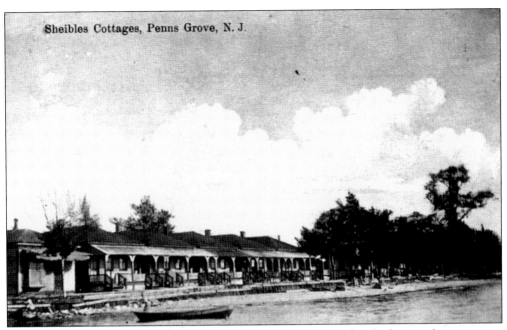

Sheibles Cottages, Penns Grove, N. J.

SHEBLE'S COTTAGES ON THE DELAWARE, 1909. After a day of sunbathing and water sports along the Delaware, Sheble's Cottages proved a handsome riverside retreat. Sheble resisted the efforts of others to pursue the construction of homes on this prime real estate. True to his call, the grove remained so, until 1915.

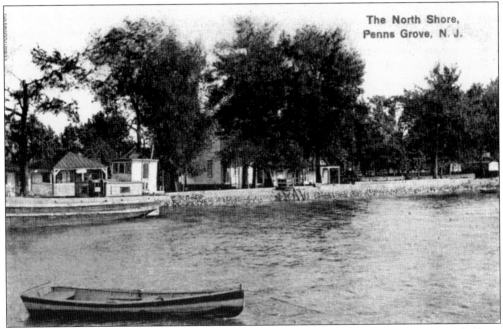

The North Shore, Penns Grove, N. J.

NORTH SHORE OF THE DELAWARE, 1909. Farther north along the shoreline, the North Shore provided more opportunities to enjoy riverside activities. Years later, the summer dwellers were replaced with families working at DuPont. It was a badge of honor to be called a "North Shore river rat."

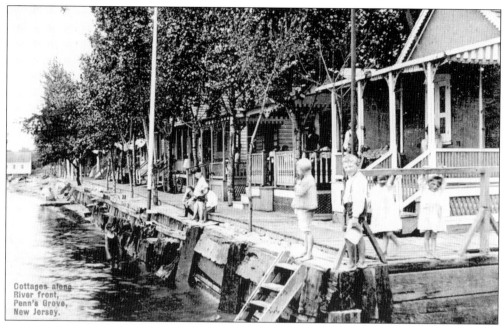

Cottages along
River front,
Penn's Grove,
New Jersey.

SUMMER COTTAGES ALONG THE DELAWARE, 1905. Just south of French's Hotel were the tiny
frame summer cottages for rent to those who came to the shore at Penns Grove. The refreshing
summer breezes off the Delaware could be felt from the comfort of a cottage porch. At high
tide, swimming and fishing were only a few steps away.

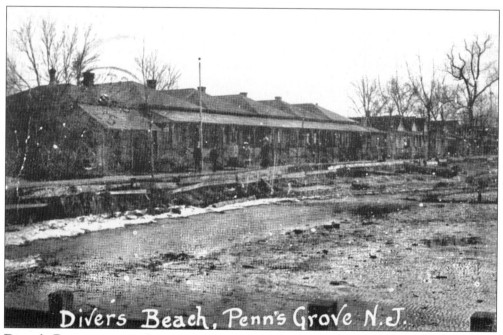

Divers Beach, Penn's Grove N.J.

DIVER'S BEACH ON THE DELAWARE, 1908. The Diver family were holders of large parcels
of property and farmland in the southern end of Penns Grove. Their property extended to the
riverside south of French's Hotel at the foot of West Main Street. Summer guests took advantage of
these shore cottages as a chance to escape the heat of the city. Many returned year after year.

Three

THE AVENUE
ON THE DELAWARE

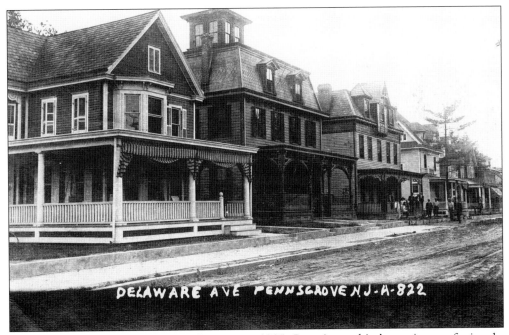

DELAWARE AVENUE, HOMES OF CAPTAINS, 1905. Prominent ships' captains, professionals, and captains of business and industry built beautiful homes along the river on Delaware Avenue. A short stroll down the street would take them to the exciting happenings at the foot of West Main Street or the amusements and entertainment in French's Grove.

CAPTAINS AND BUSINESSWOMEN, 1908. Capt. Samuel Denny built several of the homes on the blocks between Pitman and Harmony Streets. One of the homes is pictured on the left. The home on the right was built by Priscilla Brick around 1892 on land purchased from Samuel Sheble, who had purchased the land from S. R. Leap. The Brick family owned the Hardware and Feed store on Oak Street, just off of West Main Street. Sheble's Grove can be seen on the left side of the photograph.

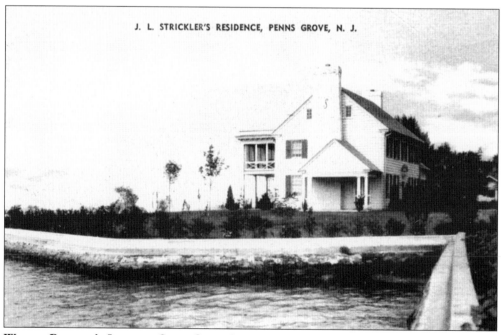

J. L. STRICKLER'S RESIDENCE, PENNS GROVE, N. J.

WHERE BARBER'S ICE AND COAL ONCE STOOD, 1935. This stately Southern-style mansion sits on the property once occupied by Barber's Boatyard, next to Elkinton's Grove. Barber had a pier and small boatyard on this riverfront property. A frame dwelling that sat on the property was destroyed by the great fire of Penns Grove in March 1932.

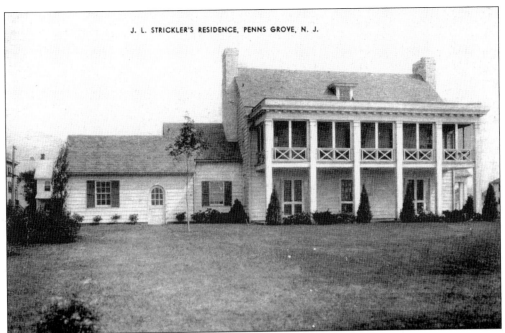

THE STRICKLER RESIDENCE, 1935. After the fire of 1932, this fine structure was built on the riverfront. Situated next to old Elkinton's Grove, the home featured an open Southern-style veranda, with columns on the river side to take advantage of the cool river breeze.

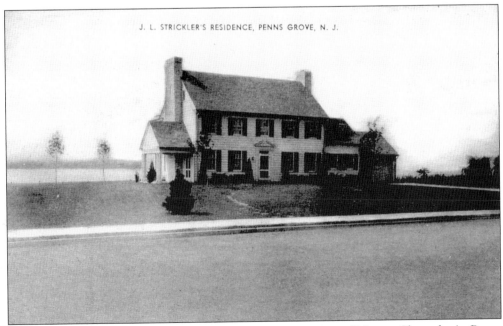

NOONE'S RIVERSIDE RETREAT, 1935. Tom Noone, owner of Noone Chevrolet in Penns Grove, would become owner of this riverside retreat in the 1940s. Noone added columns to the front entrance of the home, to match the Southern charm of its veranda on the river side. The remains of the Barber's Wharf can still be seen at low tide, to the left of the property.

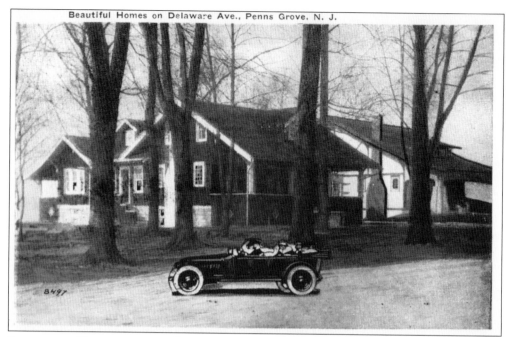

BEAUTIFUL HOMES ON THE DELAWARE, 1920. After 1915, these lovely craftsman-style bungalows were built on riverfront land once known as Sheble's Grove. They were a unique architectural contrast to the larger Victorian and American four-square homes built from 1890 to 1925, situated across the street.

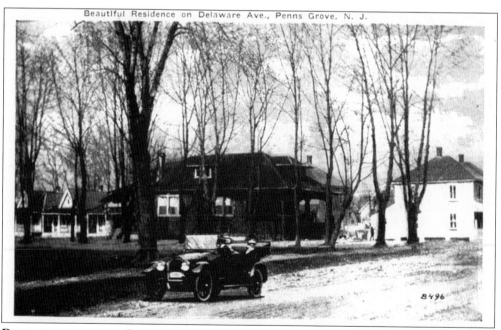

RESIDENCES ON THE RIVERSIDE, 1920. Homes built in old Sheble's Grove were one to one-and-a-half stories, affording neighbors across Delaware Avenue to still have a river view from their second and third floors. Quaint cottages still lined the side street off of the avenue on what was known as Risner's Row.

Four

THE PIER
AND ONE SQUARE

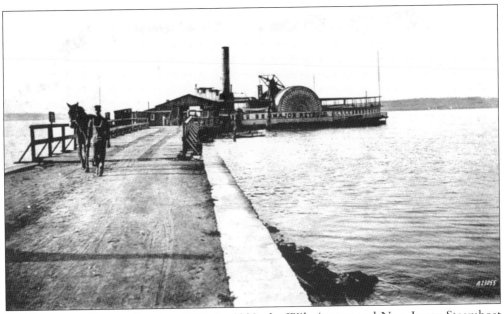

THE PIER AT PENNS GROVE, 1905. In 1829, the Wilmington and New Jersey Steamboat Company purchased a piece of land (at the foot of what is now Main Street) and built a wharf (pier) for steamboats. The original wharf was frail and was destroyed by ice flows during the winters of 1830 and 1831. Charles Elkinton, owner of Elkinton's Grove, bought the wharf in 1848, made improvements, and strengthened the bridge, but once again it was destroyed by the ice flows of 1854. In 1855, Charles Elkinton sold the old pier for $3,000 to the Pennsgrove Pier Company. In the winter of 1895, a vast area of ice in the river broke loose and carried away the middle of the wharf and the shed at the end. It was not until the dredging of the river, some years later, that the ice flows were diminished. A popular side-wheeler, the *Major Reybold*, is seen here as it docks at the pier in Penns Grove. The *Major Reybold* was built in 1853 by the Thomas Reybold Company. It was well-known for the beautiful tone of the silver ship's bell that beckoned passengers to board. It was said that the bell was made from 500 silver dollars.

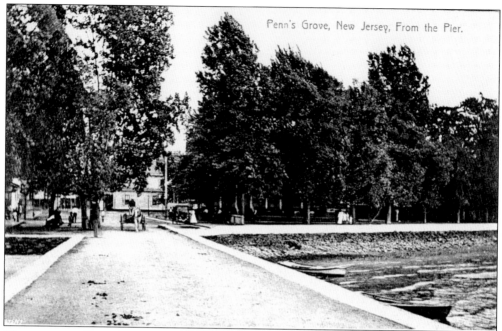

Penn's Grove, New Jersey, From the Pier.

WELCOME TO PENNS GROVE, C. 1907. A lovely view of French's Grove was the first sight seen when disembarking the *Reybold*, the *Clyde*, or the *Ulrica* at the pier at Penns Grove. The refreshing grove beckoned travelers to rest in the shade after their long trip down the river.

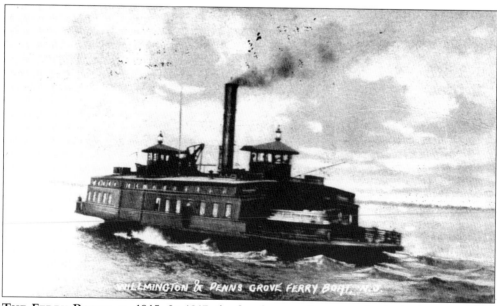

THE FERRY BOATS, C. 1915. In 1917, the ferryboats and steamers in the Wilson Line fleet were used to transport passengers from Wilmington to Penns Grove. Many of these people were transferred to trolleys headed for Riverview Beach Park in Pennsville. Ferries sometimes made 30 crossings per day.

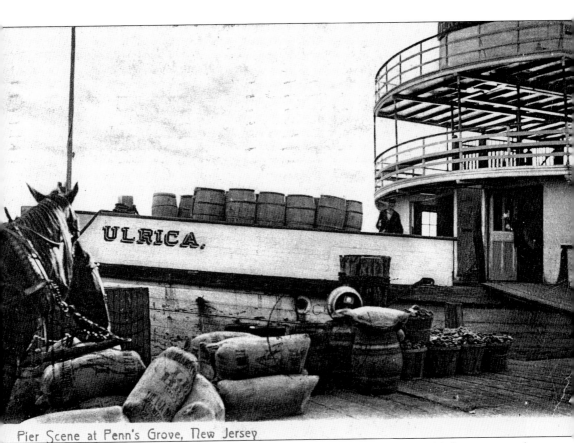

Pier Scene at Penn's Grove, New Jersey

THE STEAMER *ULRICA*, C. 1905. The steamer the *Ulrica* was built in 1893 for year-round travel to Wilmington from Penns Grove. By this time, the screw propeller was replacing the paddle wheel. The *Ulrica* carried both foot passengers and cargo. Many times, it was loaded with produce from local farms, headed for the markets in Philadelphia. The June 1902 *Salem Sunbeam* reported, "A large number of early tomatoes were shipped to market from Penns Grove this week. Never before have tomatoes been shipped so early in the season." After 23 years on the river, the *Ulrica* was sold to movie interests. It later burned in New York City during the filming of a motion picture.

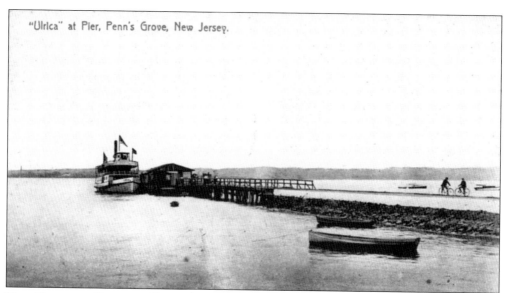

"Ulrica" at Pier, Penn's Grove, New Jersey.

THE *ULRICA* AT DOCK, *C.* 1910. The steamer *Ulrica* docks at the end of the pier at Penns Grove. During Home Coming and Civic Gala Day, 1908, the *Ulrica* experienced engine trouble and had to be towed back and forth across the Delaware all day to accommodate the over 5,000 visitors to town.

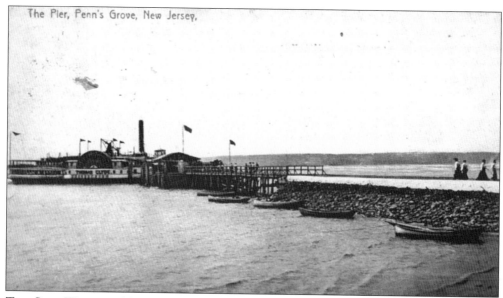

The Pier, Penn's Grove, New Jersey.

THE SIDE-WHEELER *THOMAS CLYDE*, *C.* 1903. Passengers prepare to board the well-traveled side-wheeler the *Thomas Clyde*, which made daily trips up and down the Delaware. Built in 1878 by the Thomas Reybold Company, it was known for excursions and for transporting peaches. Both the *Major Reybold* and the *Thomas Clyde* were responsible for bringing the many city residents to and from Penns Grove during the summer season. The September 1, 1888, *Penns Grove Record* reported, "200 passengers came down on the Major Reybold last Saturday afternoon to return on the Clyde and 297 on Sunday." For $1, a person could leave Philadelphia at seven o'clock in the morning, have breakfast on board, and land in Penns Grove to relax for a while. They could then return to Philadelphia on the afternoon steamboat.

NEW LINE

FROM

PENNSGROVE

TO

WILMINGTON.

ON AND AFTER AUGUST 6TH, 1872,

THE

STEAMER "BALLOON,"

Capt. Cable,

Will run regular every day, making three trips each day from Pennsgrove to Wilmington, Delaware.

Leave Pennsgrove at 6 1-2, A. M.; Wilmington at 8 1-2; Pennsgrove at 10 o'clock; Wilmington at 2 o'clock. P. M.; Pennsgrove at 4, and Wilmington at 6 o'clock, P. M.

Fare each way **15** cents; Excursion tickets **25** cents; Children **10** cents.

By order of

Capt. D. B. HALLENGER, Sup't.

SAILING ON THE DELAWARE, C. 1872. Steamers, side-wheelers, and ferries plied the Delaware River, meeting the high demand of river passengers. New lines were introduced in grand fashion with announcements posted all around town. The steamer *Balloon* mentioned in this advertisement boasts a fare of 15¢ each way from Penns Grove to Wilmington, Delaware, or an excursion fare of 25¢. The *Balloon*, manned by Captain Cable, would make regular trips three times a day from Penns Grove to Wilmington.

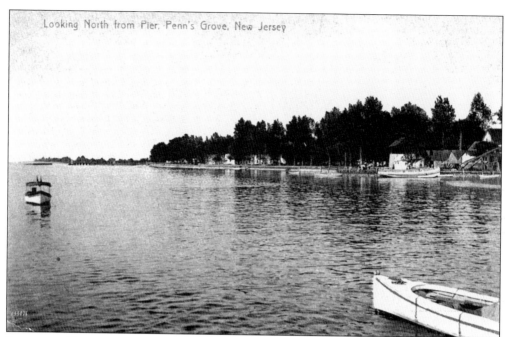

LOOKING NORTH FROM THE PIER, 1910. Edward W. Humphreys left a precious legacy of several hundred photographs taken from around 1895 to about 1930 throughout Salem County. Many of these photographs became postcards of some of his favorite scenes, such as the postcard above.

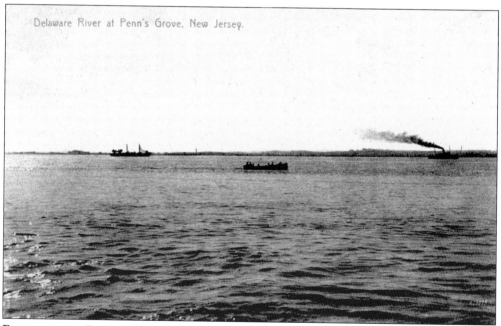

BOATS ON THE RIVER, 1910. Here is another E. W. Humphreys card of boats on the Delaware. Other familiar Humphreys postcards include many of the steamboats that traveled to Penns Grove, the *Ulrica,* the *Major Reybold,* and the *Thomas Clyde.*

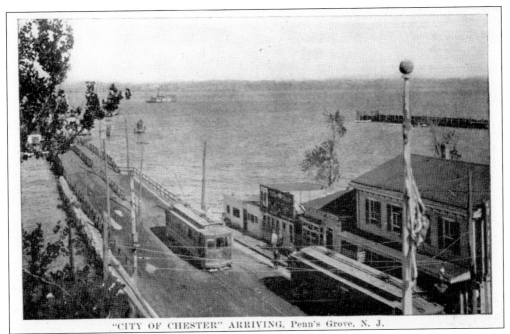

"CITY OF CHESTER" ARRIVING, Penn's Grove, N. J.

THE *CITY OF CHESTER*, 1910. The *City of Chester* ferried passengers up and down the river with stops at the pier at Chester, Pennsylvania. Trolleys wait at the foot of the pier in front of the trolley car waiting room. This view was taken from the veranda of French's Hotel.

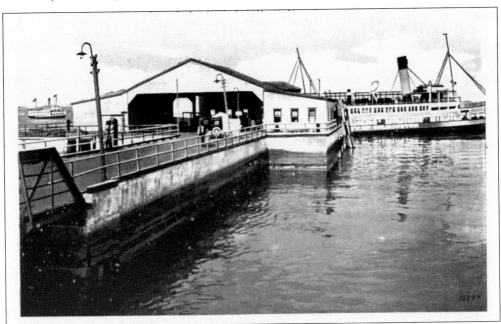

THE WILSON LINE WHARF, 1915. A variety of Wilson Line steamers docked at the Wilson Line Wharf at the pier in Penns Grove. The Wilson Line had long prided itself on operating ultramodern steamers. Excursions from Philadelphia to Chester, Penns Grove, and Pennsville were available on the Wilson Line. Moonlight cruises on the Delaware were a popular Wilson Line feature, where the dance floor was always full.

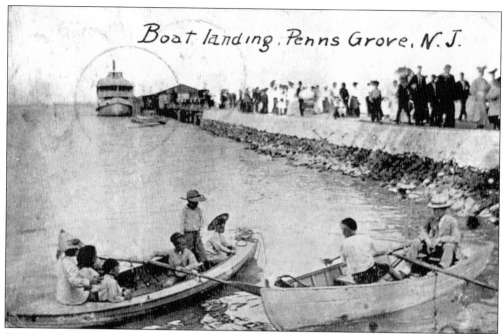

BOAT LANDING AT PENNS GROVE, 1910. Steamboat passengers arrive and depart on the pier at Penns Grove, as the *Ulrica* sits docked at the end of the pier. Two small boats serve curious spectators close to the shore at French's Grove.

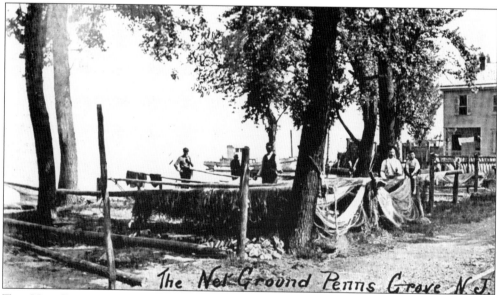

THE NET GROUNDS, 1901. The fishing, canning, and shipping industry was vital to the local economy. Nets needed to be tended to, whether in the river or not. Nets could not be stored wet and were dried on racks at the net grounds. Mending nets was also a meticulous task. The *Salem Sunbeam* reported in February 1904, "Shad fisherman are complaining of the high price of twine and cotton line. The price of the former, has been raised from one dollar and ninety five cents to two dollars and five cents a pound and that of the later, from twenty eight cents to thirty five cents a pound."

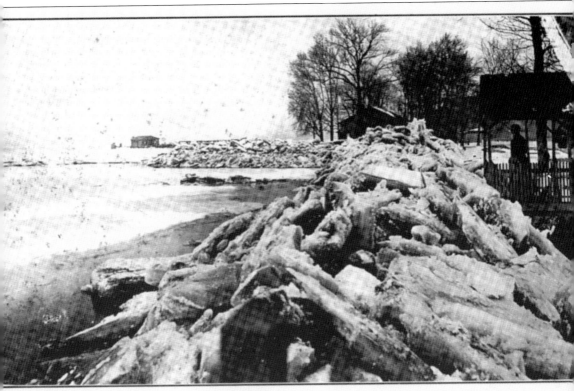

THE SHORE AT PENN'S GROVE, N. J. IN WINTER

THE ICE FLOWS COMETH, 1905. There were times that the Delaware River still froze over solid from shore to shore during the cold, hard winters. There were stories of people walking from Penns Grove to Delaware on the ice. Familiar wintertime sports such as skating and sledding were often done on both sides of a frozen Delaware River. During the winter, the steamboats were tied up in safe harbor and were not used again until the next spring. Ice flows often caused a great amount of damage to the pier, sometimes causing portions to be torn away from their pilings. The *Salem Sunbeam* reported in February 1902, "The Penns Grove Pier, which was greatly damaged by the ice, is being put in shape again." Great mountains of ice could be found pushed ashore by a strong wind. The *Penns Grove Record* reported, "At noon on February 7, 1912, a southwest wind blew the ice out of the Cove (on south shore) onto the shore between Beach Avenue and the Penns Grove Wharf. Below French's Grove, the ice was 10 to 30 feet high along the shore."

THE EARLY DAYS AT THE PIER. This early postcard of the pier at the foot of West Main Street reflects a moment in time of this quiet, little fishing village around the 1880s. As reported by the *Salem Sunbeam* in 1902, "Fish warden Thomas J. Torton of Penns Grove has had one of his sturgeon skiffs rebuilt and a naphtha engine put in which to patrol the river to stop Sunday fishing."

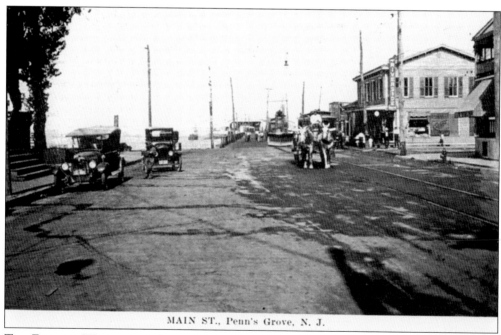

MAIN ST., Penn's Grove, N. J.

THE FOOT OF WEST MAIN, 1910. Trolleys, horse-drawn wagons, and the new Model T's could now all be found at the foot of West Main Street. The pier was a busy place with freight being loaded onto steamers, passengers going to and fro on steamers or the ferry, and more homes, businesses, and shops springing up along West Main Street.

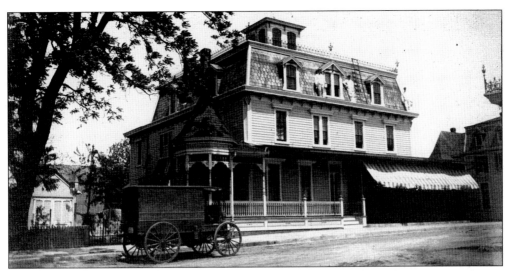

ONE SQUARE FROM THE PIER, 1913. W. S. Leap was born in 1873, the year his father, David D. Leap, built this magnificent structure. This amazing Victorian was known as the Leap Homestead, for it incorporated the business with the residence, side by side. The beauty of its construction was inspired by craftsmen who took great pride in their work. There were 12 rooms in all, with an imposing widows walk and a cupola on the roof. Advertisements of the day would say, "W. S. Leap Men's Clothier—One Square from the Pier," as the building sat one square from the foot of West Main Street across from French's Hotel. The menswear business was founded by John P. Leap in 1840, and it began as a general store directly across the street. The W. S. Leap store held the distinction of being the oldest men's store in the United States operated by a descendent of the founder.

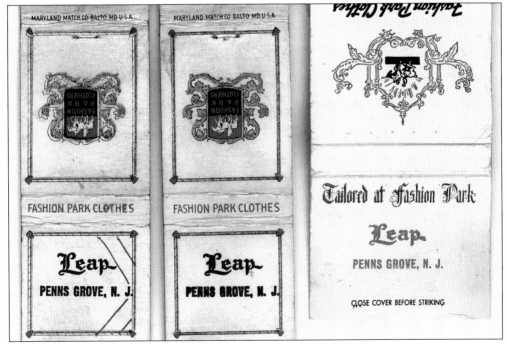

W. S. LEAP MEN'S CLOTHIERS. Matchbook covers advertise this much–sought–after shoppe. The finest men's apparel could be purchased here from head to foot, hats to shoes.

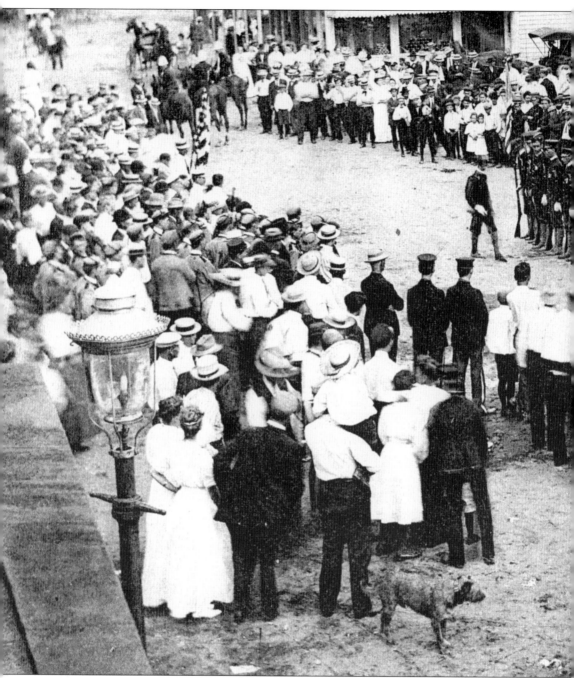

HOME COMING AND CIVIC GALA DAY, 1908. The premier event of the summer in Penns Grove was Home Coming and Civic Gala Day held in August. As reported in the *Penns Grove Record* in August 1908, "The Societies of Redmen, Jr., Order of American Mechanics, Patriotic Sons of America, Sons of Veterans and Liberty Fire Company have taken the initiative in setting apart Saturday, August the eighth, for a civic holiday, when the entire community, together with our friends and relatives from abroad, may join in those festivities and amusements that lighten the burdens, brighten the dullness and sweeten the bitterness of life. The committee has called

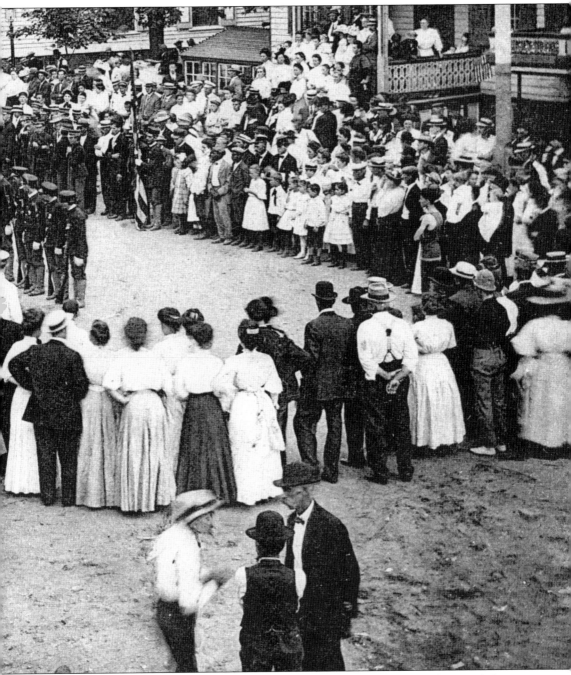

this day, 'Home-Coming Day' which means that every one who has ever lived in Penns Grove, and is still on the face of the earth, and in the land of the living, shall come HOME and renew the fellowship of the days that are past and recall the 'scenes to memory dear.'" Some of the special events included a prettiest baby contest, horse show, gun show, bicycle race, river sports, band concerts, and fireworks. "I suppose you remember this day last year," read the sentiments on this postcard dated 1909. It was reported that over 5,000 attended the gala day festivities. French's Hotel can be seen to the right.

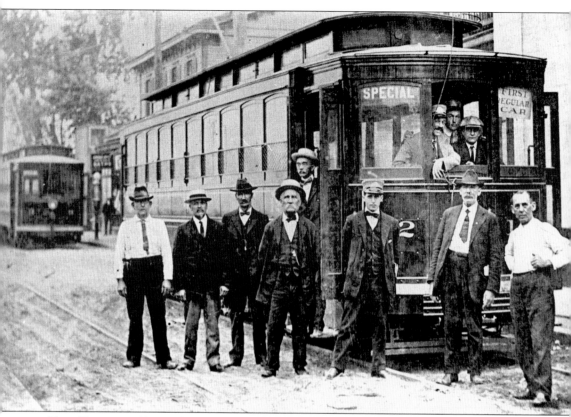

THE TROLLEY, 1916. The construction of trolley tracks began in January 1916 at the wharf at the foot of West Main Street in Penns Grove. The trolleys first ran from Penns Grove to the DuPont Plant No. 2 on August 15, 1916. Construction of the trolley line was continued to the Penns Neck Bridge at Salem by January 1917.

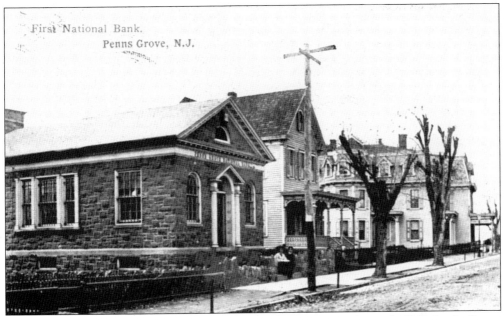

THE LITTLE GRAYSTONE BANK, 1910. A bank charter was issued in early 1900 for the Penns Grove National Bank. The original idea of organizing a bank was projected by John Danby, one of the leading bankers in Wilmington, Delaware, who at that time maintained a summer home on the riverfront in Penns Grove. Articles of incorporation were signed on May 20, 1900, and a charter was issued. The cornerstone for the new little graystone bank building on West Main Street boasts a date of 1900. Not fully completed, the bank opened in December 1900 to meet its deadline. The rear office along with other final touches were soon completed.

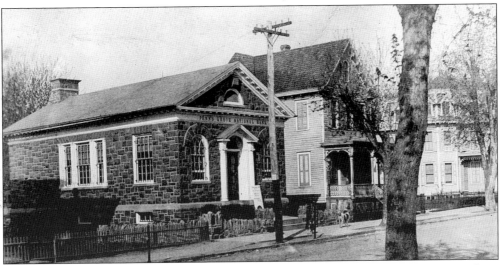

THE LITTLE BANK ON LEAP LAND, 1910. On August 24, 1900, a deed was taken from Sedgewick R. Leap for a tract of ground located on West Main Street. The tract contained a dwelling, the Leap home, and a vacant lot, on which it was proposed to build a banking house. The *c.* 1840 John Leap family homestead sits next to the little bank. The Leap family store can be seen in the background.

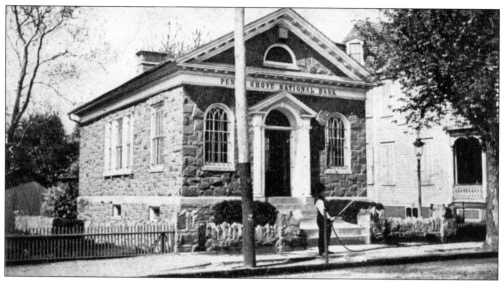

WATERING THE TREES AT THE BANK, 1910. This amusing little card shows what appears to be a gentleman watering the tree in front of the little graystone Penns Grove National Bank. After the building of the much larger bank building, the graystone building was sold to the Penns Grove Library Association. Later the property became the office of the Harry F. Stewart Insurance Agency and Stewart Realty. Today it seems that the clock will be turned back for the little bank building, as plans are being made to use it as a tourist and visitors center for the Riverwalk project slated for old French's Grove.

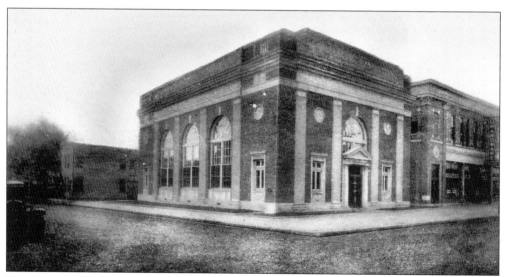

THE LITTLE BANK GROWS UP, 1930. The original charter for the bank was issued in the name of the Penns Grove National Bank. In 1928, the bank qualified to act in all fiduciary capacities, and on June 5, 1928, it secured another charter, and the name was changed to the Penns Grove National Bank and Trust Company. A much larger, more modern banking establishment was built just down the block, on the corner of West Main and Oak Streets in 1929. The new Colonial Revival structure boasted high, sculpted ceilings with gold medallions and magnificent chandeliers. Exquisite marble lined the teller's counters, and large, fanlight windows filled the hall with streams of light. The little bank was all grown up.

Five

DOWNTOWN AT
DOG TOWN CORNER

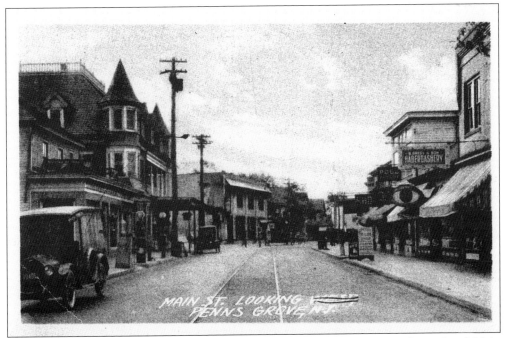

MAIN STREET LOOKING AT DOG TOWN CORNER, 1910. The corner of Broad and Main Streets was a busy place in downtown Penns Grove. First called the Cross Roads, around 1910, the intersection became known as Dog Town Corner. Early businesses on the corners were the James Sweeten, Jr.'s General Store on the northeast corner and the Dalbow Building on the northwest corner. Dog Town Corner later became known as the Square and Union Corner.

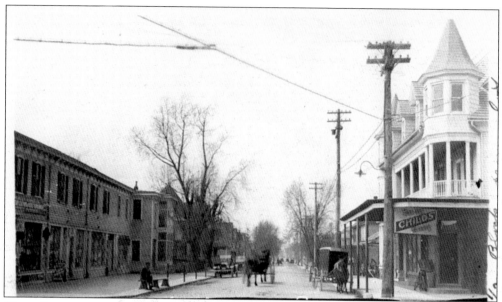

MAIN STREET AND BROAD AT DOG TOWN CORNER, 1907. The building on the northwest corner of Broad and Main was home to an apothecary and pharmacy over much of its existence, the last being Cheeseman's Drug Store. The overhang provided shade for folks, mostly men, who gathered at Dog Town Corner. On the south side of the street, businesses such as restaurants, tonsorial parlors, and professionals kept shop there. In the 1920s, John Burpulis's Paris Café had called this corner home.

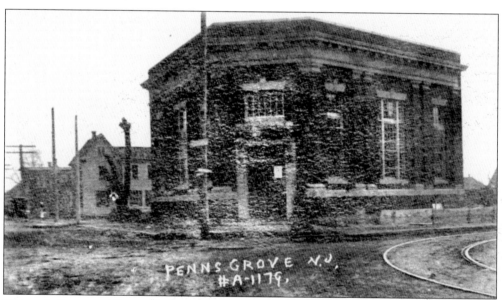

PEOPLE'S BANK ON UNION CORNER, 1917. An early photograph of the People's Bank of Penns Grove, just before its completion, shows the trolley tracks on the right on South Broad Street. In 1915, with local businesses booming and population increasing by leaps and bounds because of the war in Europe, the need for additional banking services in the center of the Union Corner business section was expressed by numerous merchants. Organization of the People's Bank, in December 1915, was the result.

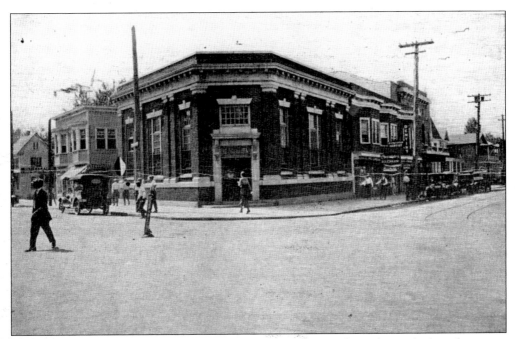

THE PEOPLE'S BANK, 1920. This card shows the People's Bank stately perched on the corner surrounded by other businesses, a newsstand and the Broad movie theater to the right, and the Penns Grove Press building to the left.

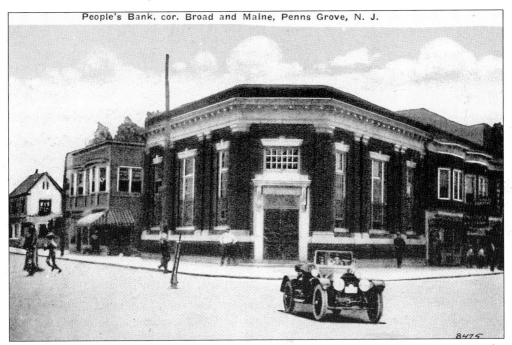

People's Bank, cor. Broad and Maine, Penns Grove, N. J.

PEOPLE'S BANK ON BROAD AND MAIN, 1920. The People's Bank of Penns Grove on the corner of Broad and Main Streets was completed for occupation in 1917. Matthew Mitchell was the bank's first president. Local businessmen like R. F. Willis, Harry Dolbow, P. P. Sweeten, and D. Summerill could be found on the board of directors.

ORGANIZED, DECE

People's Bank of

Corner Broad and Main Stre

Capital	- -	$50,000
Surplus	- -	10,000
Deposits	-	300,000

We Conduct a General Banking Business, Issue

Offer Courteous and Acco

3½ Per Cent. Interest Paid on Time A

Safe Deposit Boxes for Rent, $

BANKING HO

Open daily from 9 A. M. to 3 P. M.; duPont semi-monthly pay days from 9 A. M. to 5 P. M

915

enn's Grove

enn's Grove, N. J.

MATTHEW MITCHELL, President

FRANK J. GAVENTA, Vice-President

ORVILLE PARKER, Cashier

DANIEL V. SUMMERILL, Solicitor

DIRECTORS

L. W. Cook	Dr. C. Percy Lummis
Harry A. Dalbow	Matthew Mitchell
William P. Denny	D. V. Summerill, Sr.
Clarence Doughten	P. P. Sweeten
Frank J. Gaventa	Warren Risner

R. F. Willis

Drafts and Travelers' Checks and

ting Service

s, $1 starts an Account.

Year and Upward

8 P. M.; day following duPont pay days from 9. A. M. to 6 P. M.

PEOPLE'S BANK OF PENNS GROVE, 1917. This advertisement from the *Penns Grove Record* in 1917 touts the numerous assets of the new bank in town at Union Corner.

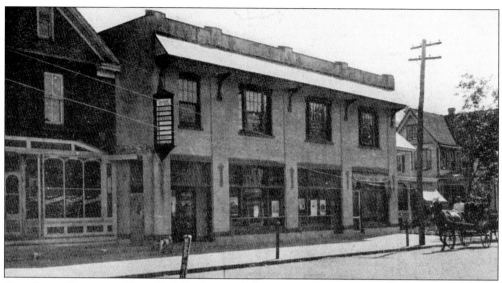

THE POST OFFICE AT DOG TOWN CORNER, 1916. During the first World War, the business center of Penns Grove expanded greatly in the vicinity of Broad and Main Streets. The merchants in that section were instrumental in having the post office moved into the Poland building adjoining Poland's store on East Main Street on December 16, 1916. It remained there for 22 years until January 15, 1938, when it moved back into the former Leap store owned by R. F. Willis and Brothers at the foot of West Main Street. The structure to the left of the post office was originally the Sweeten General Store on the corner.

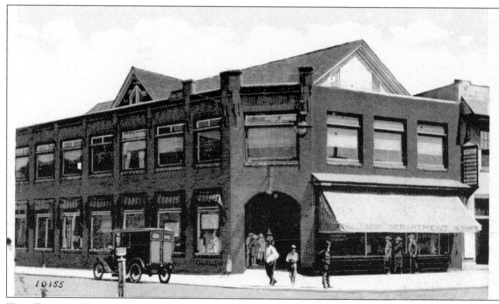

THE POLAND DEPARTMENT STORE, BROAD AND MAIN, 1920. Part of the roof of the original Sweeten Store is visible in this 1920 postcard of the new Poland Department Store on the corner of Broad and Main Streets. Poland's Jewelry Store was established under the management of Jule Poland in 1938 in the quarters vacated by the post office in the building at Union Corner, Penns Grove. Poland proved himself the same enterprising merchant as his father, M. D. Poland, whose name has been a familiar one in the local business news since 1915.

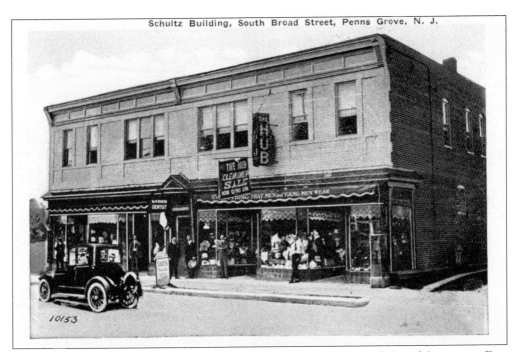

Schultz Building, South Broad Street, Penns Grove, N. J.

THE HUB ON SOUTH BROAD, 1920. The Schultz Building, on South Broad Street near Dog Town Corner, was home to the Hub, an early department store. Later the building would house the Woolworth's five-and-dime with its creaky wood floors and snappy lunch counter.

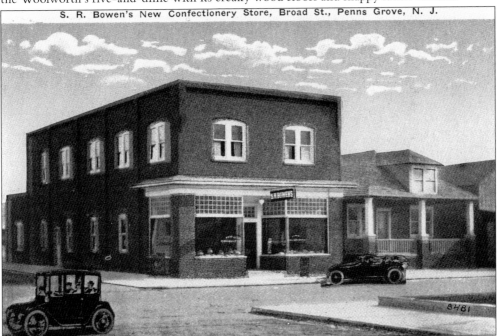

S. R. Bowen's New Confectionery Store, Broad St., Penns Grove, N. J.

S. R. BOWEN'S CONFECTIONERY, NORTH OF DOG TOWN CORNER, 1920. Sweet treats could be found at Bowen's Confectionery just one block north of Dog Town Corner. Situated just across the street from Bowen's was the new high school filled with students, ready to make it their first stop on the way home from school.

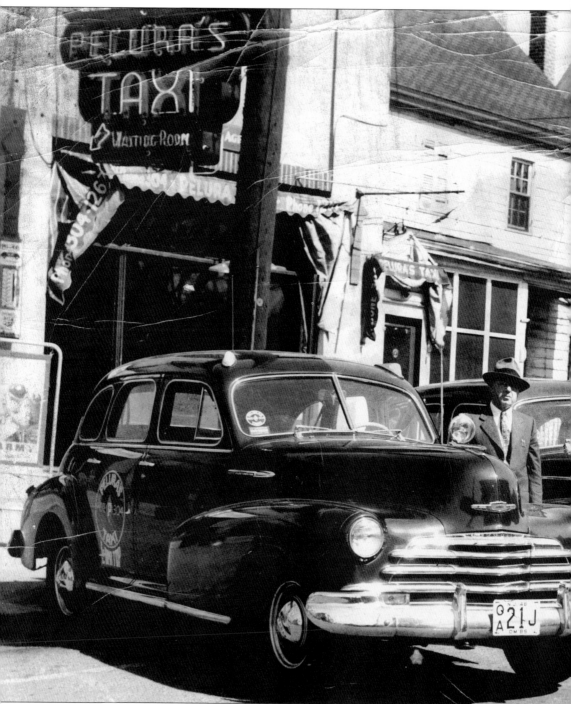

PELURA'S TAXI, 1940. In 1919, James Pelura Sr. started a taxi business, driving workers to the DuPont plant. His first office was a tiny space, the size of a phone booth. As the town prospered, so did his business. Soon he would take up residence in an office in the Poland Building on East Main Street. Taxi passengers could have a seat on the bench in front of the cabstand, under the shade of the awnings. Others could call, No. 304, for a cab. From humble beginnings with

just a small jitney, Pelura's fleet would expand to the newest, finest cabs in town. In the early 1950s, he purchased the house next to the Poland Building, had it torn down, and built his own cabstand, also adding railway freight shipping and an office for his son's business, the James Pelura Insurance Agency.

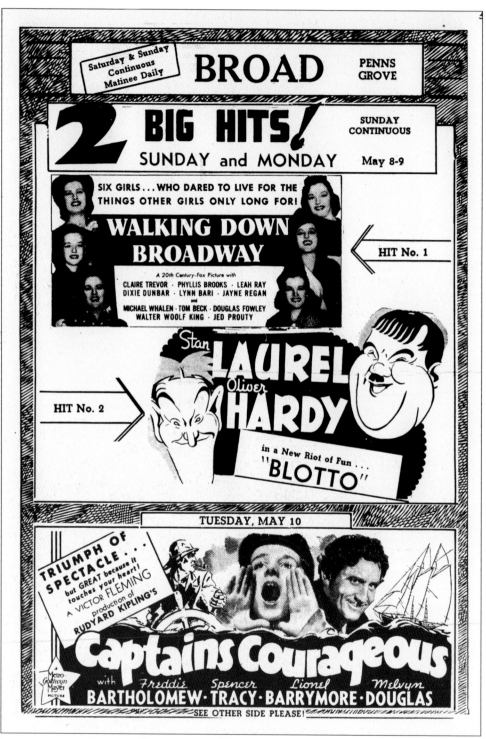

SATURDAY AND SUNDAY CONTINUOUS MATINEE DAILY AT THE BROAD. This flyer for the Broad Theatre near Broad and Main Streets in Penns Grove boasts "2 BIG HITS!" for the enjoyment of the moviegoing public.

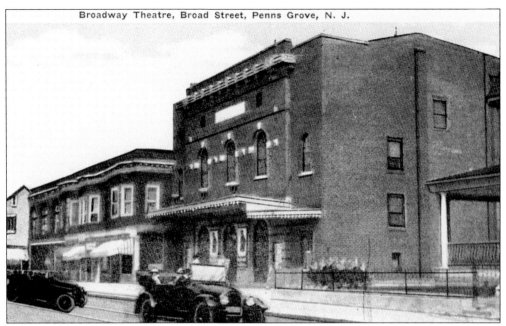

Broadway Theatre, Broad Street, Penns Grove, N. J.

No, the Broad Theatre, 1920. Sometimes postcard companies did not get it exactly right. This card calls the Broad Theatre the Broadway. Even so, it is a wonderful likeness of the old Broad. The Broad was the place to be for the afternoon matinees, glassware giveaways, or weekend talent shows. The Broad was a brick building, and inside the theater was a balcony. It was built in 1916 and opened under the directorship of Clarence Doughten and Lewis and James Workman. In 1928, the theater was furnished with a Wurlitzer Grand Organ.

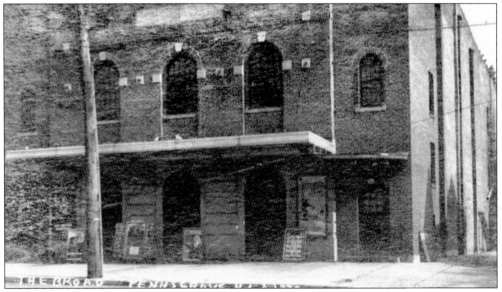

The Old Broad, 1915. An early postcard shows this vaudeville-style movie house. The Broad provided entertainment from vaudeville days to the late 1950s. At one time, there were two movie theaters in town, the Broad and the new, modern Grove just a few blocks north of Broad and Main Streets. The old Broad Theatre was later closed and demolished to make way for a contemporary drive-through window at the People's Bank.

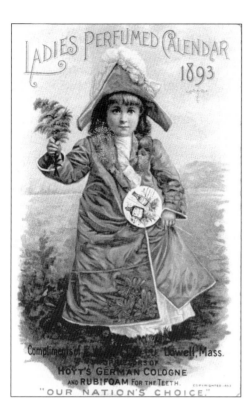

LADIES PERFUMED CALENDAR, 1893. Postcards were a popular way to advertise products. The sweet image of a beautiful blonde haired child graces the front of this postcard for Hoyt's German Cologne.

M. JOHNSON, M. D., OF PENNS GROVE, 1893. A convenient calendar is on the back of this lovely postcard from M. Johnson, M. D., of Penns Grove. Dealer in drugs, patent medicines, chemicals, fancy and toilet articles, brushes, perfumery, etc., Dr. Mayhew Johnson launched Penns Grove's first apothecary several years before the Civil War. Dr. Johnson was Penns Grove's druggist for 40 years. Dr. Johnson's daughter, B. Arete, became the first woman pharmacist in the state of New Jersey. She learned the profession as an apprentice to her father. "I was making pills at the age of 12," she once stated. She created a stir when she applied to the state board for her license, which it could not legitimately refuse because of her fine knowledge.

PERFUMED WITH **HOYT'S GERMAN COLOGNE.**
THE MOST **FRAGRANT** AND **LASTING**
OF ALL PERFUMES.
Has retained its popularity for a quarter of a Century. Do not confound it with the numerous trashy Colognes that usurp its name and style of bottle. Before purchasing see that the name is blown in the glass and the signature of the proprietors printed in red ink across the label. **REFUSE SUBSTITUTES.**
TRIAL SIZE 25 CENTS. MEDIUM SIZE 50 CENTS. LARGE BOTTLES $1.00.
Put up by E. W. HOYT & CO. Lowell, Mass., U.S.A. Manufacturers of
RUBIFOAM FOR THE TEETH.

FOR SALE BY
M. JOHNSON, M. D., Penn's Grove, N. J.,
DEALER IN
Drugs, Patent Medicines, Chemicals, Fancy and Toilet
Articles, Brushes, Perfumery, etc.

Six

ALL AROUND THE TOWN

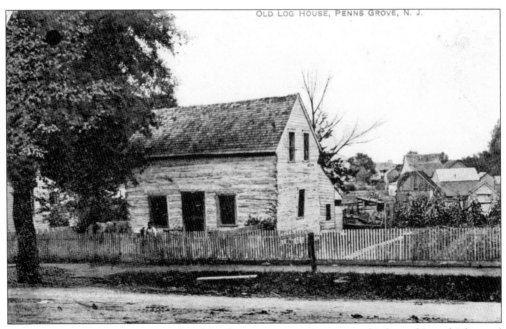

THE OLD LOG HOUSE, 1910. The oldest home in Penns Grove was this log cabin, which stood at the foot of Pitman Street near the Delaware River. It was later taken down by Benjamin Reed, who numbered each log and reassembled the house on East Main Street. In 1916, it was moved and later destroyed.

Beautiful Homes, Maine Street, Penns Grove, N. J.

8483

COLORFUL STREETSCAPES AROUND TOWN, 1920. Colorful postcards bearing artists' renderings depicting small-town life in the neighborhoods of Penns Grove became popular in the 1920s. Most of the colorized cards were published by S. R. Bowen of Penns Grove and were reproduced up until the late 1950s. This street scene shows the four-square architecture of the well-manicured homes on Main Street.

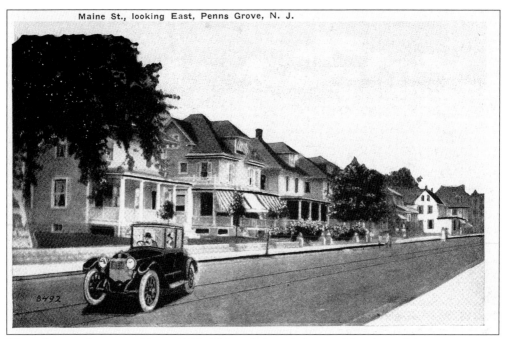

Maine St., looking East, Penns Grove, N. J.

8492

MAIN STREET LOOKING EAST, 1920. This artist's card gives a wider view of picturesque Main Street while adding a model of the automobile of the time.

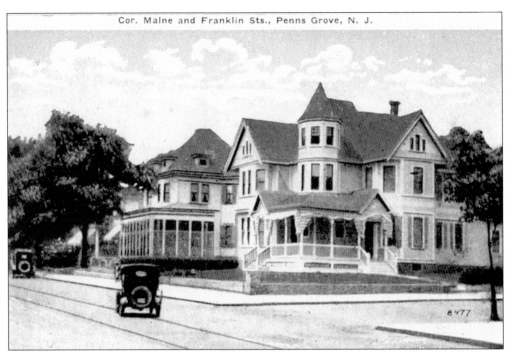

VICTORIANS AT MAIN AND FRANKLIN, 1920. This colorized card shows off the magnificent porches of the large, distinguished homes on the main streets in town.

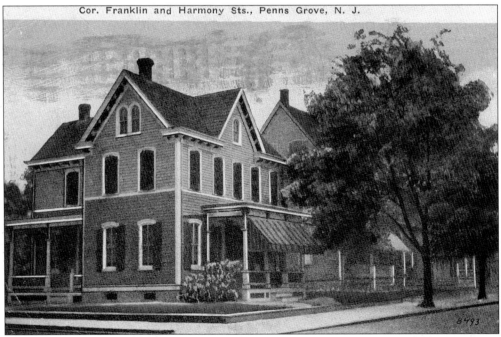

GRAND OLD ARCHITECTURE, 1920. Homes featured in the artists' cards were often shown with striking awnings and neatly manicured lawns. This card, posted in July 1921, tells Mrs. Weil of Philadelphia, "Emma is enjoying herself down here. She is learning to be some swimmer!"

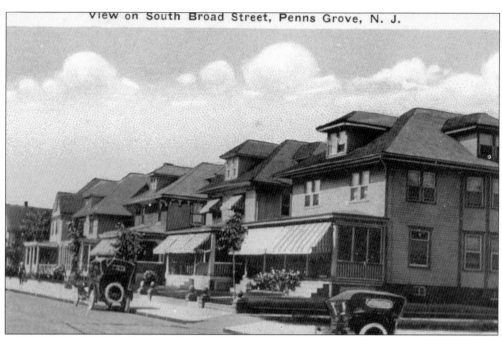

MAGNIFICENT HOMES ON SOUTH BROAD, 1920. This artist's drawing shows a familiar picture of tidy homes all in a row along one of the borough's busiest streets.

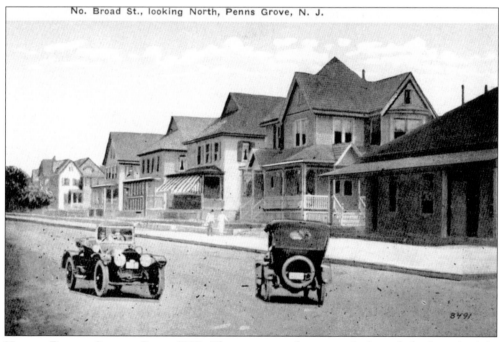

NORTH BROAD STREET LIFE, 1920. The garage on the corner is the only business in sight along this residential main thoroughfare in town between Harmony and Griffith Streets.

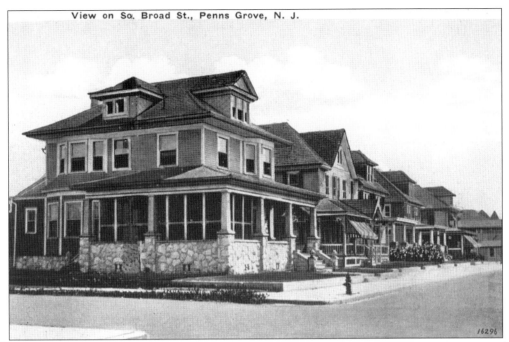

A MIX OF STYLES ON BROAD STREET, 1920. Here the artist captured the many styles of architecture that made up the town. The sturdy American four-square on the corner stands next to a gabled duplex and so on, and so on between Walnut and Willis Streets.

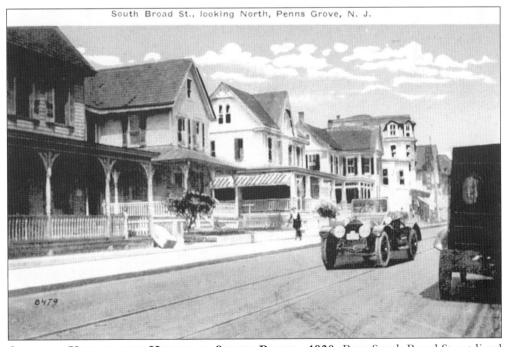

ANOTHER VIEW OF THE HOMES ON SOUTH BROAD, 1920. Busy South Broad Street lined with noble residences close to the street is captured in this artist's drawing.

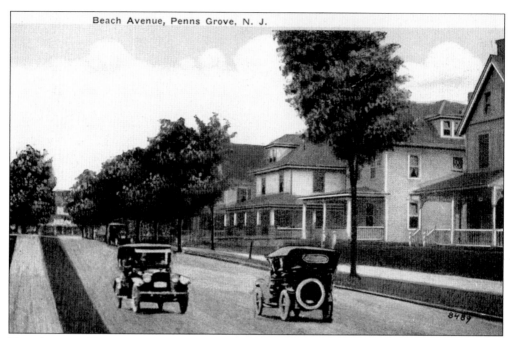

Beach Avenue, Penns Grove, N. J.

THE AVENUE THAT LEADS TO THE BEACH, 1920. Even smaller streets were chosen for the artist's rendering cards. The quiet neighborhood of the tree-lined Beach Avenue is shown here, just two blocks from the beach.

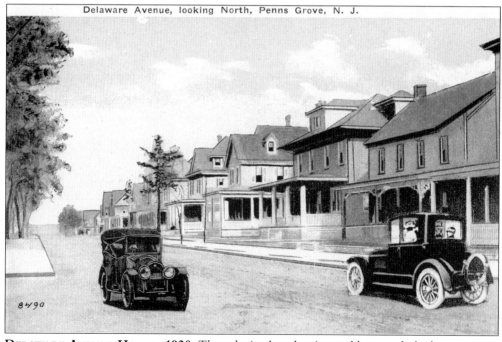

Delaware Avenue, looking North, Penns Grove, N. J.

DELAWARE AVENUE HOMES, 1920. The colorized card series could not exclude the avenue on the Delaware River. Professionals, businessmen, and ship captains called this street home and built gorgeous houses facing the Delaware.

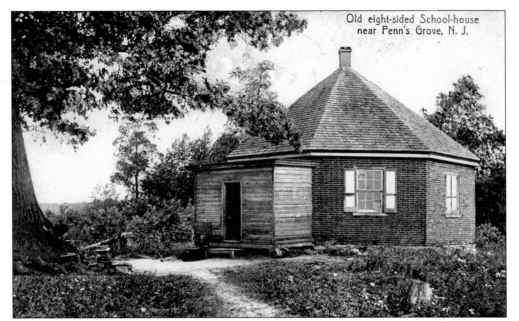

THE EIGHT SQUARE SCHOOL, 1907. Two and three-quarter miles above Penns Grove on the road to Camden stood a brick schoolhouse, generally called the Eight Square. It was built in 1821 and had a marble slab over the door on which was inscribed the name Pennsgrove. This stone can now be found at the museum of the Historical Society of Penns Grove and Carneys Point. It was donated to the museum by James and Kate Madole in honor of Kate's father, W. W. Summerill.

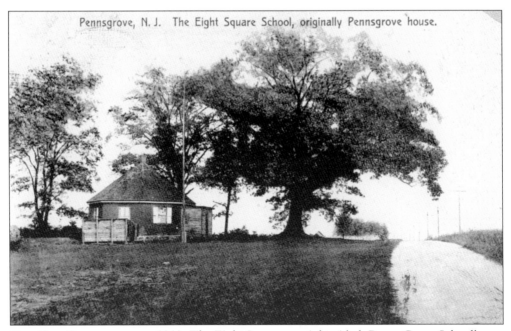

THE OLD SCHOOLHOUSE, 1910. The Eight Square, or eight-sided, Penns Grove Schoolhouse was located on the land that later was used by the U.S. military as a post, called the D. O. D., during World War II.

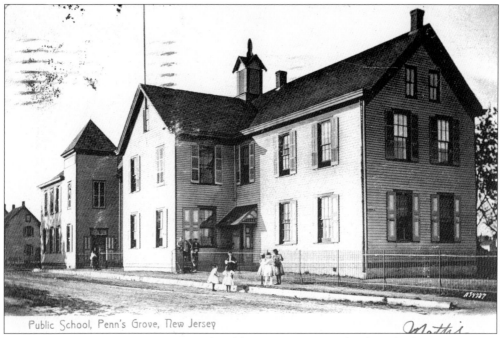

Public School, Penn's Grove, New Jersey

THE OLD WOODEN SCHOOL, 1907. The old Harmony Street School was built in 1871 on the site of the original one-story Harmony Street School, on Harmony and North Broad Streets, which was built in 1844. The second building was added around 1891. On the 1894 map, it is referred to as the Penns Grove Academy. "C. W. Cable, clerk of the Penns Grove school board has completed the school census and reports 353 children of school age in the boro," reported the *South Jerseyman* in October 1903.

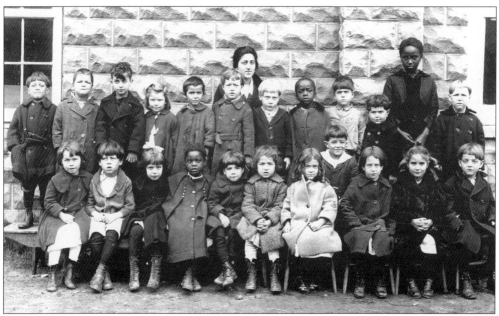

SCHOOL DAYS, SCHOOL DAYS, 1919. Schoolchildren pose with their classmates and teacher for a photograph in the old school days.

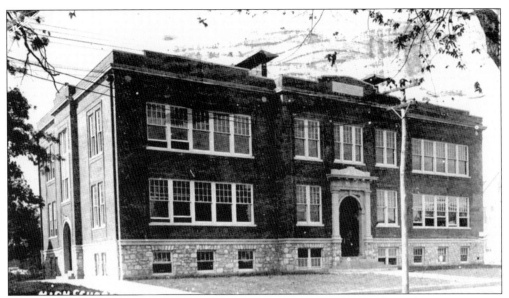

THE BROAD STREET SCHOOL, 1919. This school was located on South Broad and Harmony Streets, across from the Harmony Street School. Built in 1915, it was named Penns Grove High School. After the new, larger high school was constructed on Maple Avenue, the school was renamed Broad Street School to accommodate the elementary grades. It saw its last students in the 1980s, and, unfortunately, the Broad Street School was razed in 2004. The cornerstone is on display at the Historical Society of Penns Grove and Carneys Point museum.

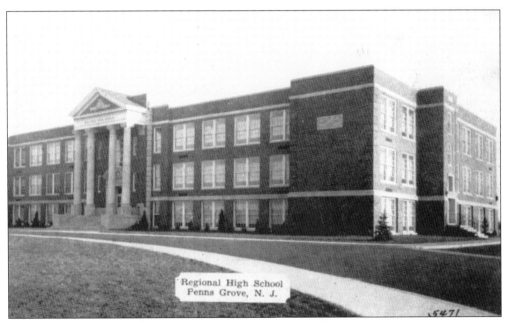

THE NEW PENNS GROVE REGIONAL HIGH SCHOOL, 1940. In 1936, Penns Grove Regional High School was built under the President Roosevelt Administration. It was a three-story building that was completed at a cost of $300,000. At the time of its construction, there were 750 students in attendance. The school became a regional high school, taking students from Penns Grove, Carneys Point, Pedricktown, and Deepwater.

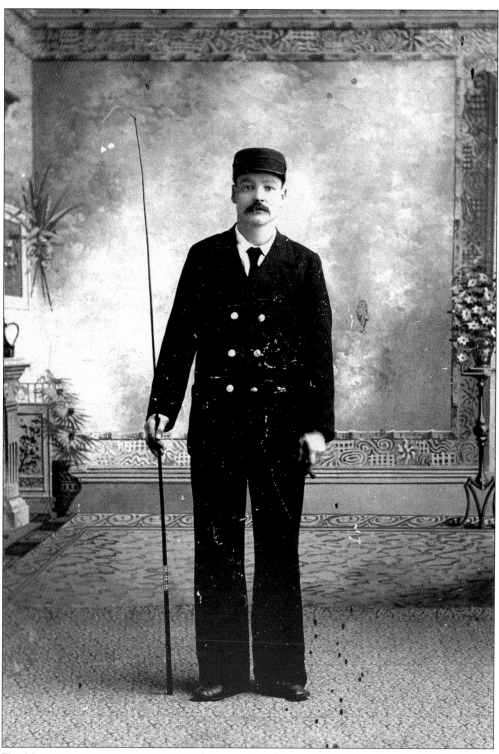

TO MOTHER FROM JAMES, 1898. This portrait of James B. Kelly is inscribed "To Mother from James."

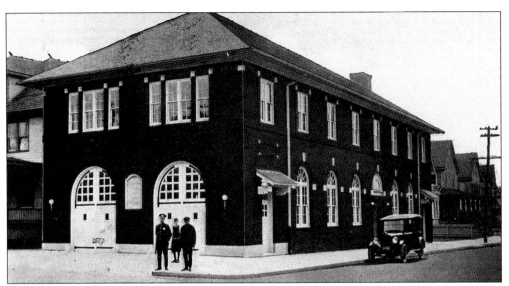

THE BOROUGH HALL, 1920. This artist's rendering shows the brand new Borough Hall. The borough of Penns Grove had become incorporated in 1894. In the pale, yellow sunlight of Tuesday, March 6, 1894, 390 of the 435 voters turned out to decide if they wanted to separate from Upper Penns Neck. Those in the cove were unanimously against it, while many who lived at the pier favored a borough. The ballots were cast and the measure carried by 44 votes, 217 to 173. James D. Torton, the town undertaker who had been a leader in the drive for the new borough, was elected mayor, Amos Morris became assessor, and Capt. Joseph D. Whitaker became tax collector.

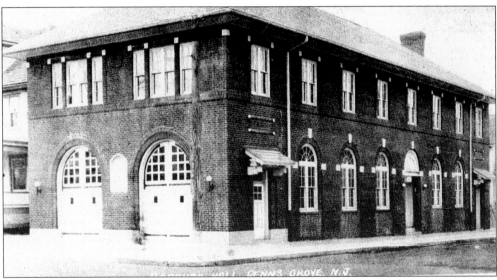

THE BOROUGH HALL, 1920. The officers of the new borough of Penns Grove were sworn in on Wednesday morning, March 28, 1894. At their second meeting on April 28, 1894, they agreed to rent the front office in the old record building on Oak Street and seven feet of the printing office for a jail. The purchase of an iron cage for the jail was authorized for $160. The council room and jail continued to be used for borough purposes until Fredric Gentieu became mayor. Town meetings were then held at the Justice Building on West Main Street until the present Borough Hall was built and occupied in 1920.

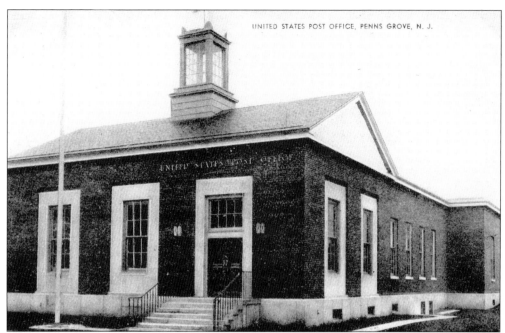

THE U.S. POST OFFICE, 1940. The first post office by the name of Penns Grove was established on March 27, 1844, with David Smith as postmaster. However, mail came to this region as early as 1826. Then an unofficial post office was in use in the general store at Helm's Cove until about 1840. Abraham Lincoln appointed Sedgewick R. Leap postmaster on April 22, 1865. Rural delivery was established in 1903 with city delivery service established in 1917. By 1940, Penns Grove had completed a new federal post office on West Main Street.

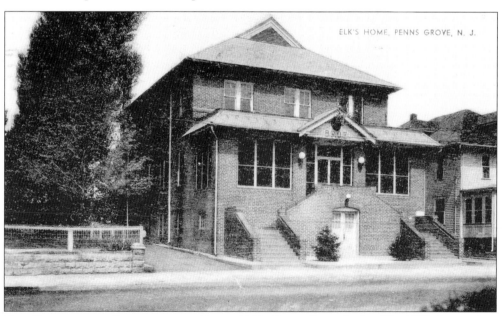

THE BENEVOLENT ORDER OF THE ELKS, 1940. Penns Grove Lodge No. 1358, Benevolent Protective Order of Elks, was chartered on July 10, 1918. The charter carried the names of 80 members. The lodge moved into its new home, pictured here, in 1923.

THE LOYAL ORDER OF THE MOOSE, 1940. The Penns Grove Lodge, No. 820, of the Loyal Order of the Moose was organized in 1915 with 87 members. During the war boom, from 1915 to 1918, the membership rose to over 800. It was during the boom period that the old Moose Home, at South Broad Road and Mitchell Avenue, was built. It served as headquarters until this building, pictured above, was purchased in 1930 from Fredric Gentieu. The building was only partially completed and had been intended for a private dwelling. The lodge extensively altered the plans and finished it to meet the organization's needs. The Penns Grove Lodge No. 820, Loyal Order of Moose, celebrated its 25th anniversary on October 26, 1940, by burning the mortgage on its $50,000 clubhouse on the corner of West Main Street and Naylor Avenue. The fraternal order had occupied its spacious home since 1930. This is a copy of a color artist's rendering of the Loyal Order of Moose home.

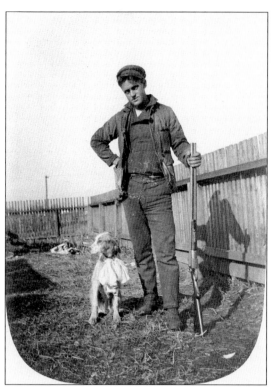

SPORTSMAN P. JAMISON, 1915. Seen here is local sportsman Preston "Pressie" Jamison with his trusty dog.

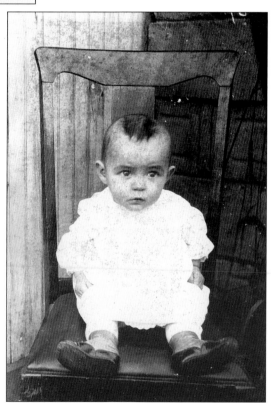

P. JAMISON'S SON, 1915. Preston Jamison Jr. looks unsure of being photographed at his young age.

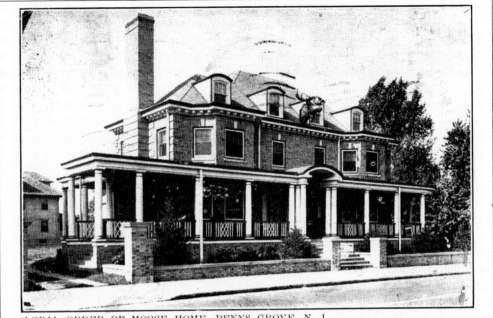

THE LOYAL ORDER OF THE MOOSE, 1933. This magnificent building was sold when the lodge purchased the property known as the Gravel Hole on North Broad Street in the 1960s and built a new, modern facility there. The old home was then sold. It was later used as an antique shop and residence.

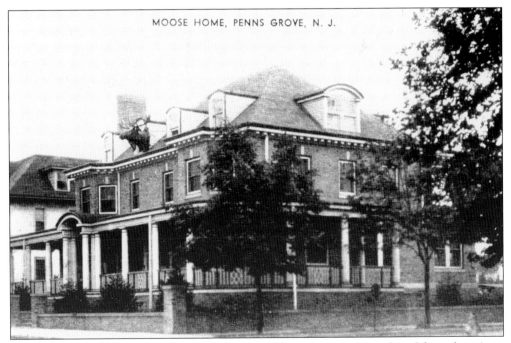

THE OLD MOOSE HOME, 1940. In 2004, the old Moose home was purchased from the private owners and is being painstakingly restored to its former glory by a local businessman and his investment company, the Delaware Avenue Group.

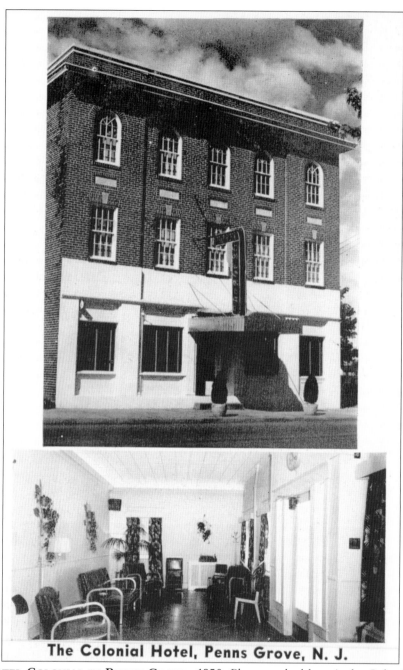

The Colonial Hotel, Penns Grove, N. J.

THE HOTEL COLONIAL IN PENNS GROVE, 1950. Photographed here is the Colonial Hotel on West Main Street, off Virginia Avenue, in Penns Grove. This card states that the hotel is near South Jersey resorts and nearby cities with air-cooled rooms, reasonable rates, and free parking. Built in 1918 by the E. I. DuPont Company, the Colonial was considered a new and more modern hotel than the 1840s frame French's Hotel down the street. The land the hotel was constructed on was first deeded to George Wiley, then sold in 1865 to Thomas Naylor. When Naylor passed away, the property was left to Hannah Summerill. In March 1916, Hannah sold the land to Annie and Joseph Schunder, who in turn sold it to the E. I. DuPont Company.

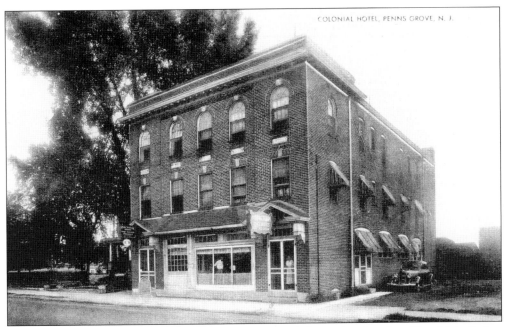

COLONIAL HOTEL, 1930. The Colonial Hotel was a stylish, modern hotel on West Main Street. After operating the hotel for over 20 years, the DuPont Company sold the hotel to the Jacquette family. The Jacquettes retained ownership of the hotel for six years.

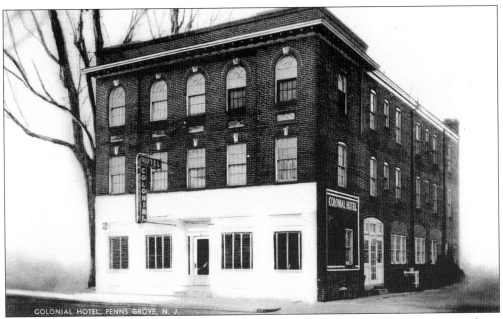

COLONIAL HOTEL, 1940. Looking at this photo card of the Colonial, many changes have been made to the façade. The old-fashioned doors and windows with awnings are replaced with a sleek art deco design. This updated look gave the hotel a sophisticated 1940s look. The Colonial Hotel was purchased by Oliver and Madelyn Allen in February 1945. With the passing of Madelyn Allen in 1975, the hotel was passed on to her son, Donald O. Allen. The Colonial has remained in the Allen family for the past 60 years.

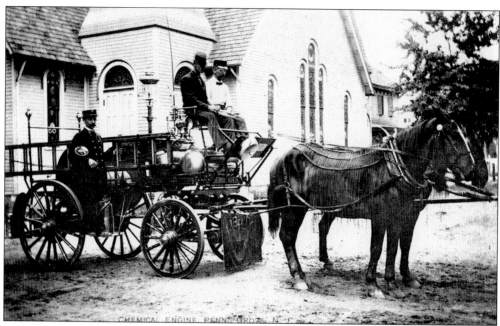

LIBERTY FIRE COMPANY NO. 1, 1905. Penns Grove's first fire department was organized in 1905. The Liberty Fire Company No. 1 is shown here with its horse-drawn chemical engine in front of the Mariner's Bethel Church on the corner of Penn and Harmony Streets. The first firehouse was on the corner of Penn and Harmony Streets, opposite the church.

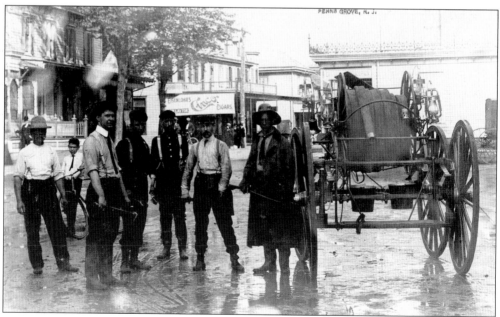

LIBERTY FIRE COMPANY NO. 1, 1905. Local fireman are pictured with the first pumper at the foot of West Main Street in front of French's Hotel. The buildings to the left are the W. S. Leap Clothiers and the Layton Tobacco Store on the Summerill block. The building behind the pumper is the original Leap General Store. The Liberty Fire Company celebrated its centennial in 2005.

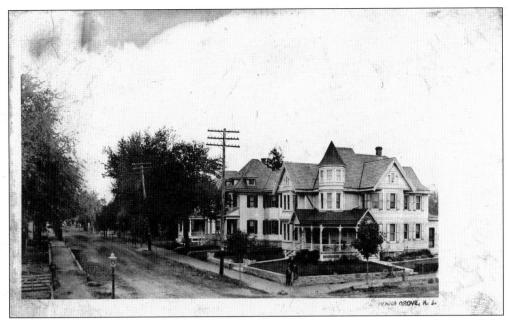

EARLY PHOTO CARD OF FRANKLIN AND MAIN STREETS, 1910. A bird's-eye view of the corner of Franklin and Main Streets shows off the grand Victorian in the forefront. It is noted as the Harris homestead on the 1894 map of the borough.

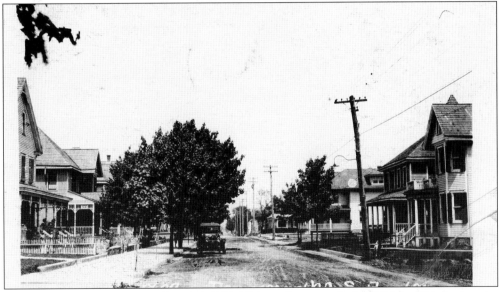

AN EARLY LOOK AT SOUTH BROAD, 1910. This card, postmarked 1916, is an early look at the residences on South Broad Street. The identification on the bottom of the card shows that this was one in a series of cards that were taken around town at that time. Postmarked 1916, Catherine pens to her aunt in Philadelphia, "Dear Aunt Margerate-We are in Penns Grove and are having a good time. I wish you were here." Catherine even identified the names of the neighbors on the street on the back of this card: Raine, Dubois, Waddington, Jacquette, and Layman, and on the other side of the street, Guest, Crumlish, Sam Sparks, and Layman. This shows South Broad Street looking north, between Beach Avenue and Church Street.

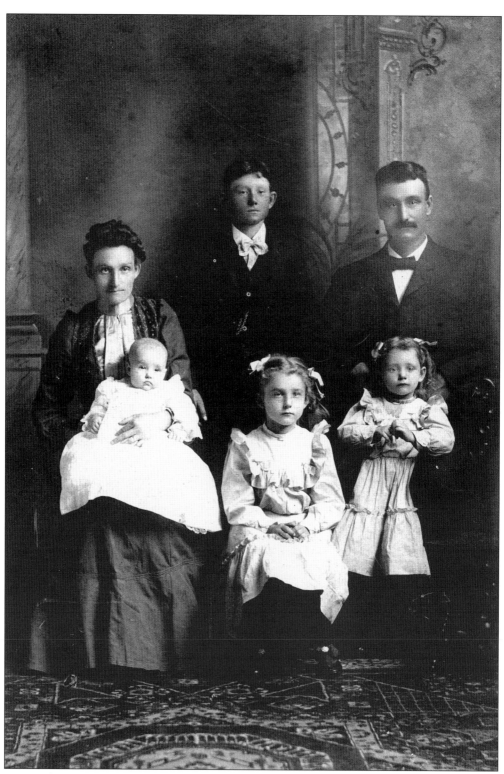

SIMPLE FAMILY PORTRAIT, 1898. Relatives of the Cook family are seen here.

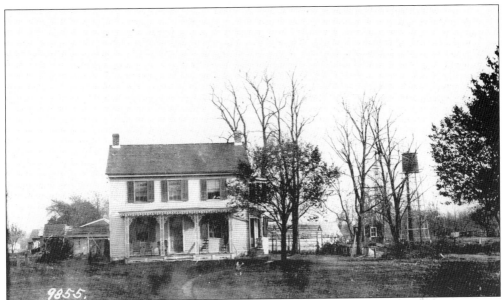

THE SMITH FAMILY FARM, 1910. This early photograph shows the 1850s Smith family farmhouse on South Broad Street. The Smith family owned and farmed much of the land on the south east part of Penns Grove. Most of the land was later sold for housing and became streets with names like Smith, Walnut, Torton, Cumberland, and others. A family-owned floral business was still in operation on the Smith property until the late 1960s.

DECORATIVE HOME ON OLD STATE STREET, 1905. This decorative family home was built in 1882. It was owned by a Mr. Mulhern, who was believed to be a bartender at the basement bar at French's Hotel. Later the home was occupied by David Johnson, the county fire marshal. This lovely home now belongs to borough natives Carmella and Wilber Sickler. The Sickler family once owned a small hotel near the pier.

WOMEN ON A MISSION, 1900. A group of women gather in town for what appears to be a medical mission. The Mother and Child Welfare office was once located in the old Leap store at the foot of West Main Street.

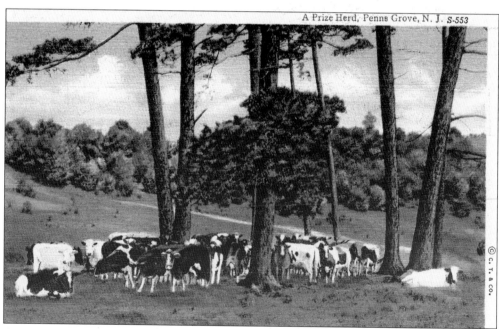

A Prize Herd, Penns Grove, N. J. S-553

A DIFFERENT KIND OF GATHERING, 1920. This prize herd could be found grazing on the many farms on the outskirts of town in nearby Carneys Point.

Seven

FAITH OF OUR FATHERS

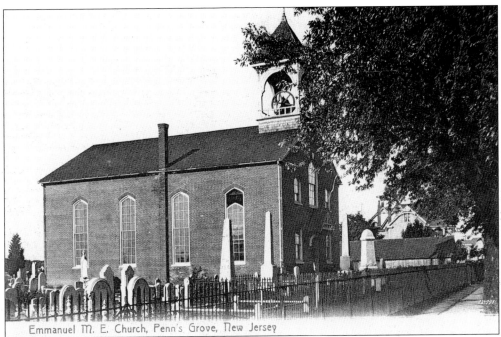

Emmanuel M. E. Church, Penn's Grove, New Jersey

THE OLDEST CHURCH IN PENNS GROVE, 1901. The Emmanuel Methodist Church was the first and oldest church in Penns Grove. Preaching services started in 1834 in the one-room country school known as Helm's Cove. The first Methodist class was formed by John Boqua in 1836. Boqua was known as the "Father of Penns Grove Methodism." The church was formally organized in 1844. This building was built in 1846 on land purchased from John Smith, on South Broad Street, at a cost of $2,200.

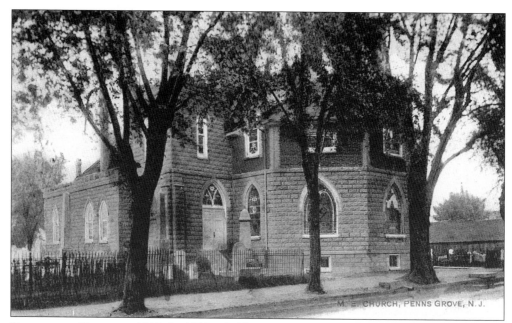

EMMANUEL CHURCH, 1910. In 1901, a belfry tower with a beautifully toned bell was added to the original Emmanuel Church. By 1907, the Sunday school had increased in membership to the extent that further renovations were planned. Wings were added to the sides, providing more space for the classrooms.

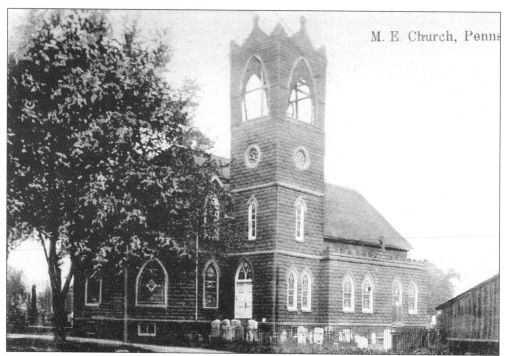

A PICTURESQUE VIEW OF EMMANUEL, 1910. This beautiful card published by B. Arete Johnson of Penns Grove shows the lovely transformation of the Emmanuel Church in 1901. To the left, one can see the stable where churchgoers could park horse and wagon.

ARTIST'S CARD OF EMMANUEL, 1920. This artist's rendition of Emmanuel Church in the 1920s shows a large cemetery and the livery stable next to the church. The Wesley Hall was erected behind the church on Church Street in 1956 to provide modern facilities for educational programs, and in 1959, the old church was replaced with a new, Colonial Revival structure.

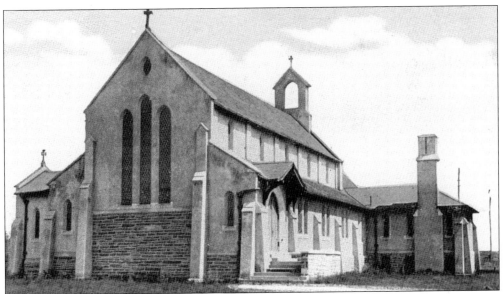

THE CHURCH THAT DUPONT BUILT, 1920. Another of S. R. Bowen's artist's cards of the Church of Our Merciful Savior on Maple Avenue near the cove is seen here. The Merciful Savior was built in 1917. An Episcopal church built by the DuPont Company under the direction of Rev. Charles Barton duBell, it is a replica of a 12th century French Gothic church located near Nemours, France. The church has a majestic, Gothic look with breathtaking stained glass. The first service was held in a tent on July 11, 1915. The cornerstone of the church was laid on June 26, 1917.

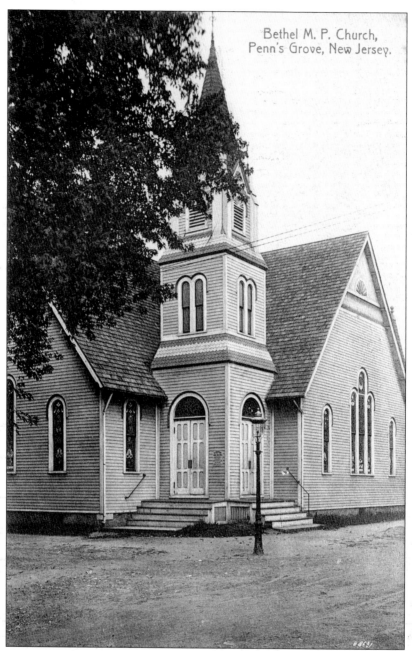

Bethel M. P. Church,
Penn's Grove, New Jersey.

BE YE FISHERS OF MEN, 1910. This is another E. W. Humphreys photo postcard of the Mariner's Church on Penn and Harmony Streets. At the beginning, the church was known as Fisherman's House of God. In 1860, local preacher Joseph Guest and a few others left the established Emmanuel Methodist Church and began the Bethel Mariners Methodist Protestant Church. Those who had established the church felt there was little being done to reach the fisherman or boatman for the Lord. A small church building was built on land owned by Guest. The church was incorporated in 1877, and by 1894, there were so many people attending that the original church had to be torn down to make room for a larger facility, and this lovely sanctuary was put in its place on the corner.

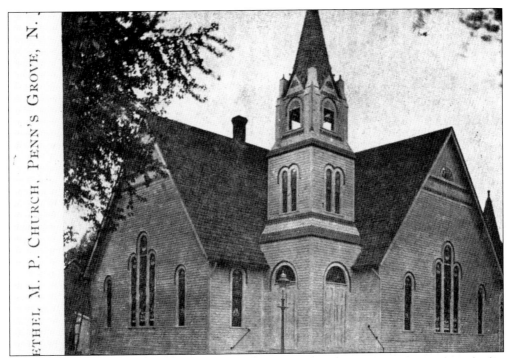

THE MARINER'S CHURCH, 1905. An earlier photo postcard of the Bethel Mariner's Methodist Protestant Church inscribed in 1907 says, "Dear Mother, Arrived safe in Penns Grove!"

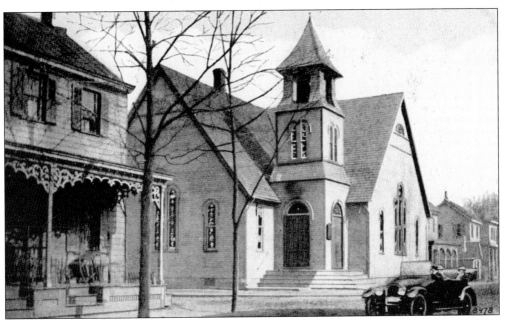

THE CHURCH AND NEIGHBORHOOD, 1920. An artist's drawing shows the lovely Bethel Church surrounded by residences in its neighborhood on Harmony Street. This picture would change drastically when in March 1932, the Bethel Church, along with countless numbers of homes, were destroyed by fire. The neighborhood would never look the same as in this timeless portrait. The church would build a new brick sanctuary on the same site the following year.

THE PREACHER'S WIFE, 1900. Mrs. Rainie, the preacher's wife, is photographed here.

ST. PAUL'S METHODIST CHURCH, 1910.
In July 1878, a group organized a Sunday
school and began meeting to plan a church.
In April 1880, a plot of land, about an acre in
size, on the corner of Harmony and Franklin
Streets was purchased. In October 1884,
construction was started on St. Paul's. A
service of dedication was held on February
19, 1885, and that same year, 120 men and
women from Emmanuel Church became
charter members of St. Paul's.

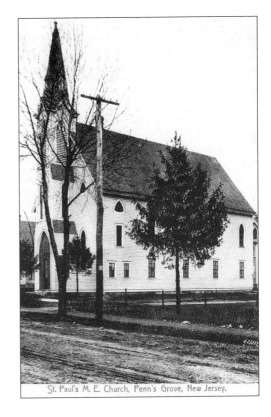

St. Paul's M. E. Church, Penn's Grove, New Jersey.

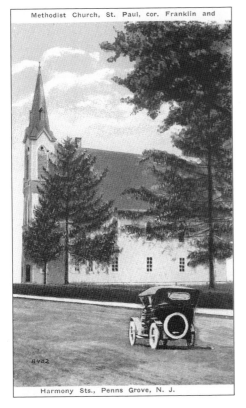

Methodist Church, St. Paul, cor. Franklin and
Harmony Sts., Penns Grove, N. J.

**ST. PAUL'S ON FRANKLIN AND HARMONY,
1920.** Over the years, changes and additions
were made to St. Paul's Methodist Church. A
grand pipe organ was installed, a parsonage
was erected, and a kitchen and social hall were
built. The original church itself was rebuilt in a
Colonial Revival style in the 1950s. This artist's
rendering shows the original St. Paul's church.

ONE OF THE GIRLS, 1900. She is identified only as "one of Sara Cross's girls." As was the custom, many times professionally taken photographs were reproduced onto postcards, giving a postcard greeting a personal touch.

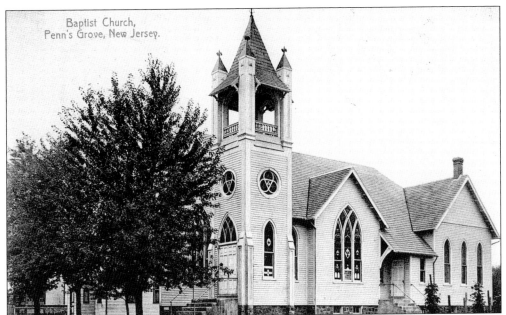

THE FIRST BAPTIST CHURCH OF PENNS GROVE, 1910. The First Baptist Church was organized in June 1892 with just nine members. The first place of meeting was in the business establishment of Thomas J. White on Main Street, and later the church met at Turner's Hall on West Harmony Street. In March 1894, a 20-by-30-foot chapel was erected on State Street. The congregation had grown over the years, and in 1907, under the ministry of Rev. H. S. Kidd, this splendid structure was dedicated. This is an E. W. Humphreys card, as well.

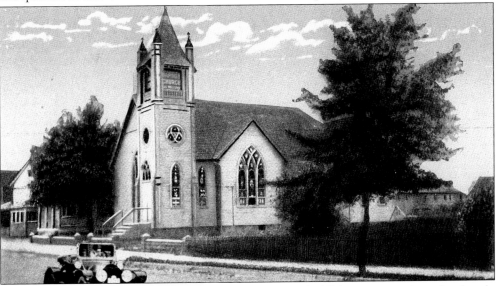

THE BAPTIST CHURCH ON STATE, 1920. In 1911, several additions were made to the church. The enlarged lecture room was rented to the public school system for a primary department and later became the parsonage. In 1920, the glorious baptistery and three classrooms were also added. In 1949, two restrooms and a classroom were added. In 1956, a ground breaking took place to erect a new church on a site in Carneys Point. The old church was taken over by the Odd Fellows and was later sold to a private owner.

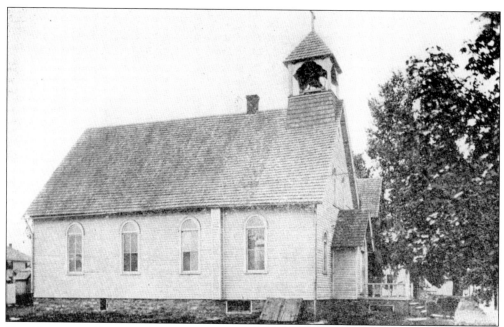

THE CATHOLIC CHURCH ARRIVES, 1910. On June 14, 1898, the Reverend Walter Leahy, who was stationed at Swedesboro, offered the first mass in Penns Grove in the home of Thomas Durr, on Pitman Street. In 1900, the church became a mission of Woodstown, with mass celebrated twice a month. In 1901, the parish was regularly incorporated as St. James Church, and a new church was built on North Broad Street.

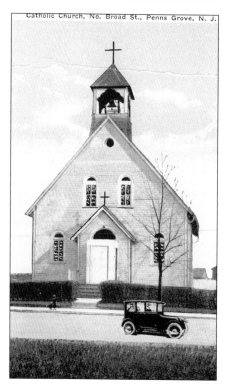

Catholic Church, No. Broad St., Penns Grove, N. J.

THE MISSION BECOMES A PARISH, BECOMES A SYNAGOGUE, 1920. With the employment of thousands at the DuPont plant during World War I, it became evident that the little Catholic church would not accommodate the crowds who came to hear mass. A large number of Italian families, who were Roman Catholic, came to Penns Grove at this time. They wished to bring the traditions of their homeland to the church in their new hometown. In 1919, Rev. Hugh Massey was appointed the first pastor and St. James designated as a separate parish. Plans were made to build a larger facility on Beach Avenue that included a parochial school, and the new church and school were completed in 1921. The small building on North Broad Street then became home to the Synagogue-Shari-Tzadeh organized by Penns Grove businessmen Charles Charlap, David Dumoff, and Isodore Weinburg. Synagogue-Shari-Tzadeh afforded local merchants of the faith a chance to worship close to home and store. Today the building is home to an independent Christian church.

Eight

THE DAY
THE TOWN BURNED

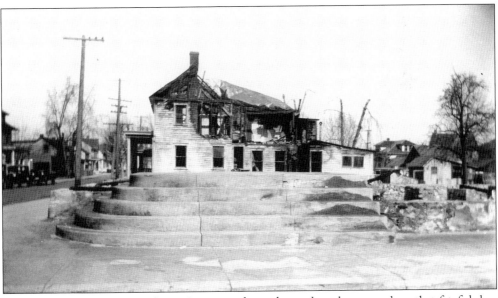

BETHEL CHURCH, 1932. The entire town almost burned to the ground on that fateful day, March 1, 1932, when a fire, swept by blustery, winter winds off of the Delaware, engulfed a six-block area near the pier. Shortly after lunch, the alarm went up from the blacksmith's shack on Barber's Wharf on Delaware Avenue at the foot of Harmony Street. The fire quickly spread from one building to another, and the destruction had begun. Only the charred steps remained of the Mariner's Bethel Church on the corner of Penn and Harmony Streets.

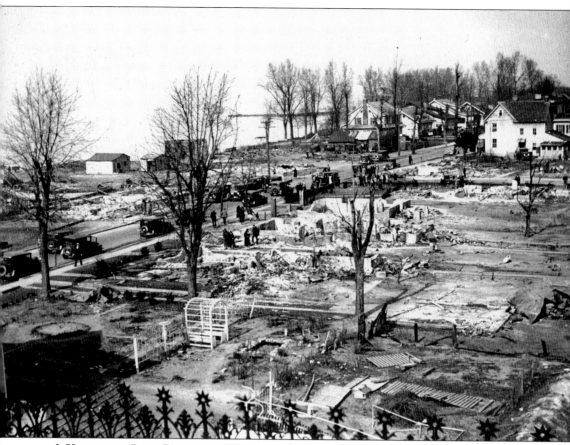

A View from Leap Building, 1932. An unknown photographer perched on the roof of Leap's Clothiers on West Main Street, captured the widespread damage done by the fire. Most of the residences on the first block of Delaware Avenue were completely destroyed. Valiant efforts had been made by the firemen, but to no avail. Fire companies from Deepwater, Pennsville, Salem, Camden, Thorofare, Atlantic City, and across the river on the ferry from Wilmington and Philadelphia, came to the aid of Penns Grove. Fifty-two fire companies from three states responded to the call. Fighting alongside the fireman were 400 DuPont employees.

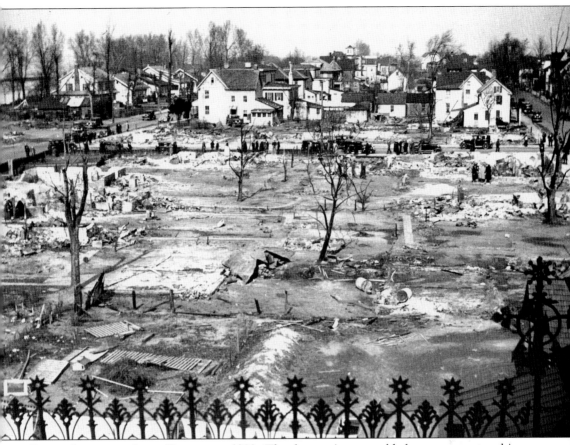

FROM ATOP THE LEAP BUILDING, 1932. The destruction resembled a war zone, touching homes, trees, and gardens. The smoke from the quick-moving fire could be seen for miles. The choking smoke reached throughout town. Sen. S. Rusling Leap was attending a meeting in Trenton when word came that his hometown was burning, as residents scrambled frantically to remove whatever they could from the burning homes. Delaware Avenue can be seen to the left and Penn Street to the right.

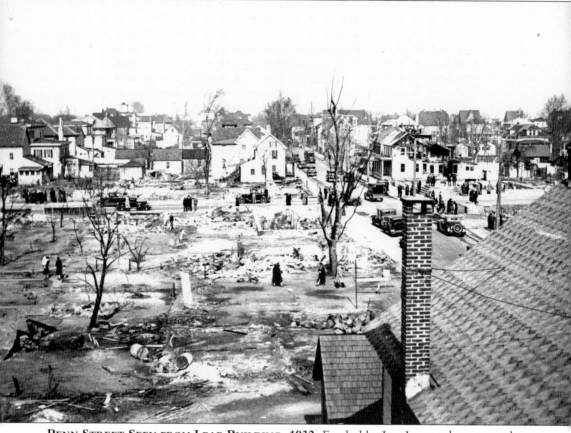

PENN STREET SEEN FROM LEAP BUILDING, 1932. Freeholder Jere Long, whose general store was on the corner of Penn and Harmony Streets, lost all. Just across from the Mariner's Bethel Church, Long's grocery burnt to the ground. The livery stables behind the Leap property were also destroyed. Another factor hampering the firemen was water needed to douse the flames. They had hoped to use the river as a source, but due to the extreme low tide caused by the wind, it was almost 45 minutes before a Wilmington pumper on the Wilson Line Pier was able to obtain sufficient water and suction to raise water from the river to fight the fire. Five pumpers were used in all, with water coming from the Perkintown waterworks and the DuPont supply.

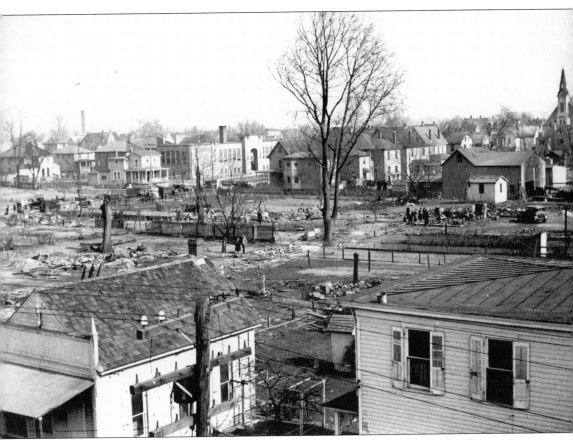

LOOKING TOWARD HARMONY STREET FROM LEAP BUILDING, 1932. The destruction continued down Harmony Street as large homes were devoured. The Harmony Street School, to the left, and St. Paul's Methodist Church, seen with the steeple to the right, were in the fire's path. Luckily, they were spared. The Penns Grove National Bank was used as a first aid station. Considering the magnitude of the fire, very few injuries were sustained.

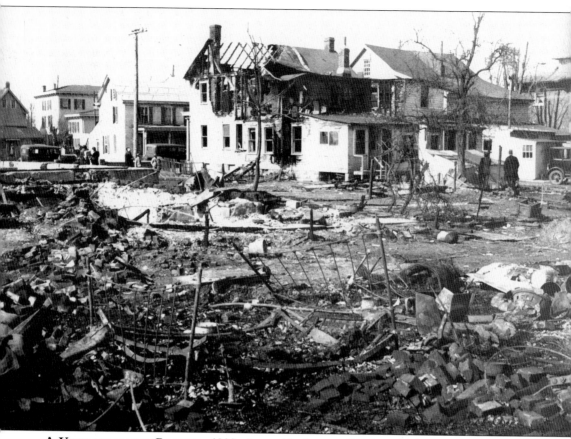

A VIEW FROM THE GROUND, 1932. A two-block area of 60 homes, the homes of 250 people who were left homeless, was destroyed by the voracious flames. Homes a half mile away had been threatened. An estimated amount of over $300,000 worth of damage was done by the fire, and the National Guard was called in and martial law was declared to prevent looting.

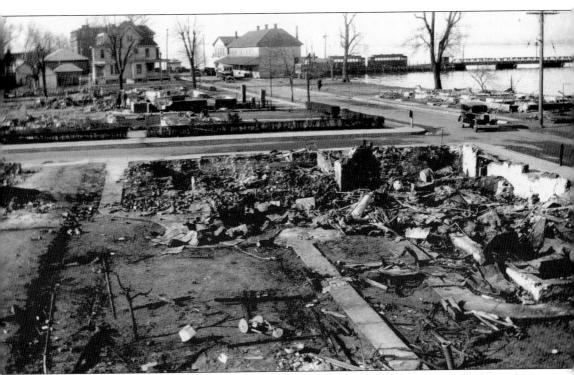

DELAWARE AVENUE LOOKING TOWARD THE PIER, 1932. Total devastation is seen on the corner of Delaware Avenue and Harmony Street, just across the street from the Barber's Ice and Coal wharf where the fire originated. Almost nothing remained of the first block of Delaware Avenue. The insurance companies acted quickly after the fire, providing monies for the families as early as the next day. Forty percent of those families were determined to rebuild on the site of the ruins. Trolley cars can be seen waiting near the pier, and the top of French's Hotel can be seen in the back of the photograph.

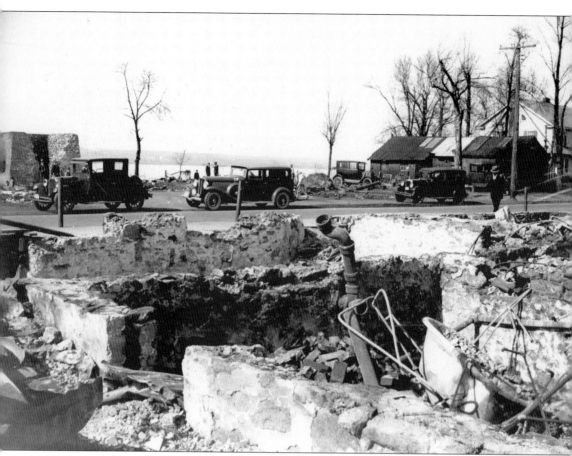

A SOLEMN PROCESSION, 1932. From the corner of Harmony Street looking across Delaware Avenue, a procession of onlookers view the devastation. Following the fire that nearly burned the town down, curious spectators, numbering the tens of thousands, toured the ruins on Delaware Avenue, Penn Street, and Harmony Street. A burned cast-iron bathtub can be seen in the right corner of this photograph. Even in this total destruction, the people of Penns Grove vowed to rebuild.

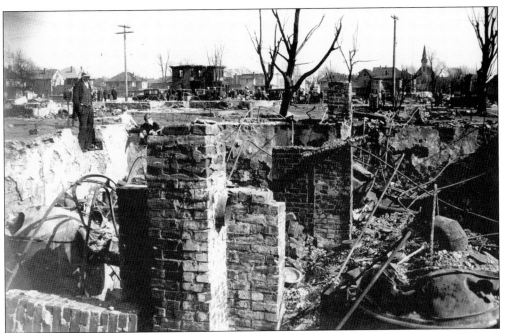

CHARRED REMAINS, 1932. Only charred remains of foundations and chimneys were left of the fine, frame residences. On March 10, nine days after the great fire, it was reported that strong winds had whipped up some of the still-smoldering embers, and a booster tank engine was sent out to patrol the fire-swept area from 1:00 a.m. until 3:00 a.m., extinguishing any sparks that had been stirred.

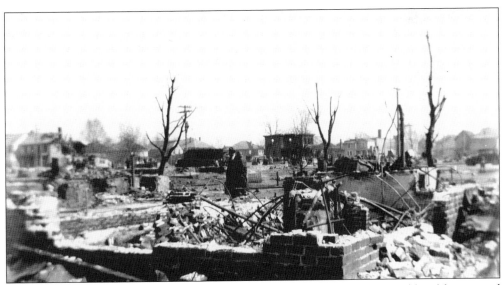

AMONG THE RUINS, 1932. A wider view of the fire's destruction, as neighbors' homes and trees were taken, can be seen here. Later many new homes were constructed where the original structures stood, as the community and its neighborhoods were restored.

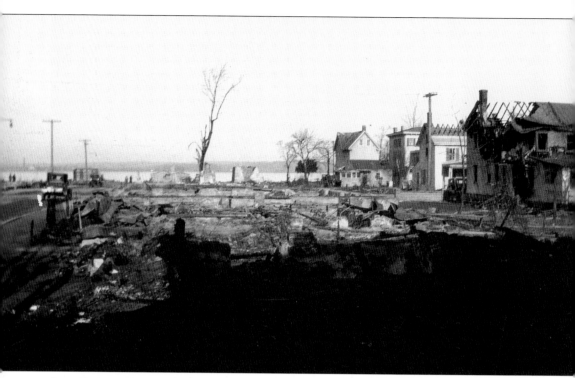

ACROSS FROM BARBER'S PIER, 1932. Homes on the corner of Delaware Avenue and Harmony Street, across from Barber's Pier, were in the direct path of the wind-driven flames. They were the first to go. Although the fire leveled six blocks, the effect was felt by the entire town. Smoke damage, flying debris, and ash covered an additional six city streets, making a total of 12 town blocks that were damaged or destroyed. The unfortunate combination of fire, wooden frame structures, and a freak March nor'easter's high-velocity winds made for one of the most damaging fires in the whole of Penns Grove's history.

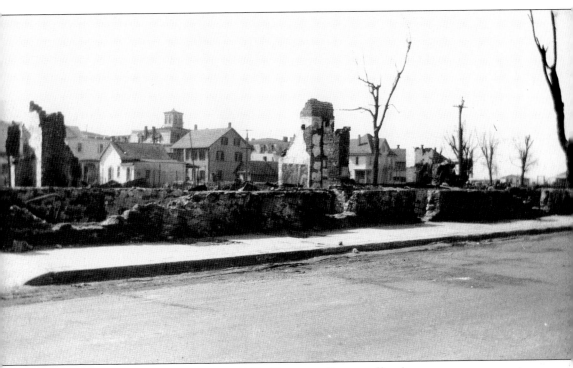

HARMONY STREET AT THE RIVER, 1932. Harmony Street suffered an enormous amount of damage from the uncharitable flames. Homes and businesses were leveled. Only charred foundations remained. The residents of Penns Grove were more than grateful to all who came to their aid during the great fire of March 1, 1932. At a banquet held later that month, all the fire companies who had responded to the call were honored. The governor of New Jersey, A. Harry Moore, sent a letter of recognition to the firefighters for their swift and courageous actions. Along with the firemen, there were thousands of volunteers who helped save the town from burning down.

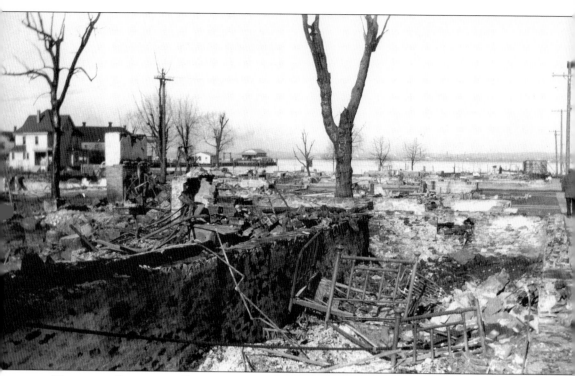

HARMONY STREET AT DELAWARE AVENUE, 1932. Looking toward the river, one can see the pier to the left, charred trees, and the shattered remains of homes on Harmony Street. On March 2, 1932, the front page headline of the *Wilmington Morning News* read "Lindbergh Baby Kidnapped." Above the headline read, "Hundreds Left Homeless in Penns Grove Fire." March 1 would be a day that would remain a sad one in the hearts of the people in this country, with added sadness for those who were touched by the flames of the great fire of 1932 in Penns Grove.

Nine

CARNEYS POINT AND THE VILLAGE

SHELL ROAD, 1909. Steamships would land bushels of oyster shells at Barber's Wharf in Penns Grove. The oyster shells were put down on the streets throughout the borough and on the main road in Carneys Point. Oyster shells were ideal for wagon travel. The wagon wheels ground the shells into dust, which left a comparatively smooth surface for wagon wheel travel and was still sufficiently resilient for horses hooves, thus the name, Shell Road.

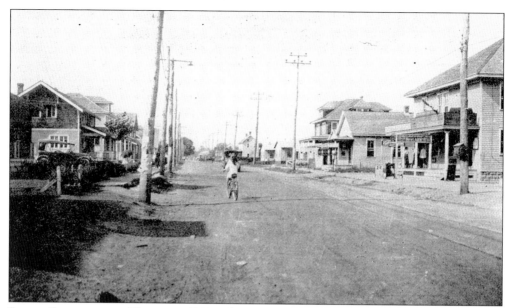

SHELL ROAD IN THE VILLAGE, 1918. This World War I scene of Shell Road in the Village shows a crop of merchants have been added since the boom brought by the DuPont Powder Works. The Oliver Barber Shop and home can be seen on the right. Shell Road in the Village became merchants row, offering services to those in the Village such as a poolroom, Kirsch's Candy Store, automobile servicing stations, and grocers like Pagano's.

SHELL ROAD, 1918. To handle the influx of workers and their families, DuPont arranged for temporary housing to be constructed. In May 1915, DuPont was expecting 75 carpenters to arrive from Baltimore and 400 to arrive from New York. This would be the start of the building of the Ruberoid Village. They were known as Ruberoid houses because they were covered on the sides with vertical strips of Ruberoid, with wooden strips covering the edges of the Ruberoid, as seen here on Shell Road. The construction proceeded rapidly. Ruberoid bungalows were among the first type built between Shell Road and the Delaware River.

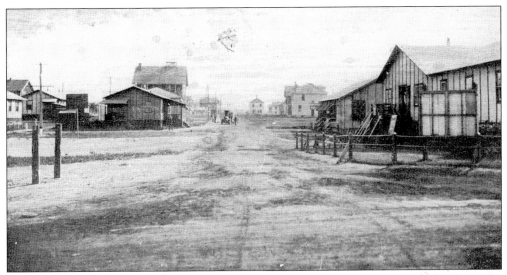

The Alphabet Streets, 1918. The streets west of Shell Road were named alphabetically, e.g., "D" Street, and those near Georgetown Road were known as Avenue "C," etc., but were changed to have the names of more recent U.S. presidents such as Taft and Coolidge. During World War I, there was a large group of buildings near "D" Street that contained the Quarter Master's Office, where the collection of rent and the maintenance of the village homes, streets, etc., was handled. A doctor's office occupied by Dr. G. B. Underwood and a drugstore that he operated were in this group of buildings.

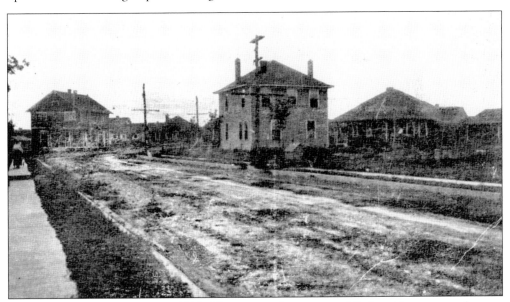

Broadway in the Village, 1918. There were three types of Ruberoid temporary houses: six-room bungalows, four-room, one-story houses, and two-story row houses, often referred to as the barracks. The bungalows rented for $8.50 per month with a $1 a month charge for electric services. The four-room houses rented for $5.50 a month, and the barracks rented for $8 a month. Many bungalows were ready to be occupied by June 1915, and the houses on Washington Street were ready by the fall of 1915. There were 450 of the barracks built by 1917. Streets in the Ruberoid Villages were lined with cinders.

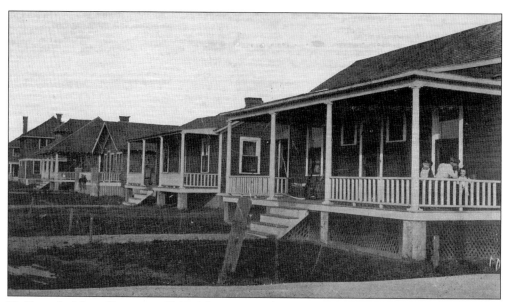

DuPont's New Village, 1918. There were also permanent houses built in the Village. The permanent houses were built using precut lumber. Along with the temporary housing, permanent houses sprang up all around the Village. In June 1915, J. A. Bader Company was given a contract to build 12 permanent houses in the Ziegler tract near the entrance to the DuPont Plant No. 1. There were 66 houses in the Ziegler tract. By 1917, there were 131 permanent houses built in the Village.

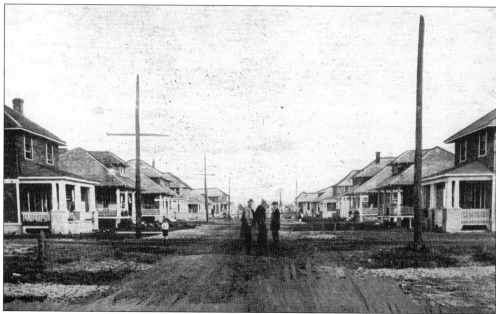

A Village of Families, 1918. The Ruberoid bungalows, four-room row houses, two-story row houses, and the permanent homes turned farmland into neighborhoods. By 1948, some of the bungalows were torn down, while others in the Village were improved by the DuPont Company and offered for sale to tenants at a low price. Many took DuPont up on their offer and made Carneys Point their hometown for good.

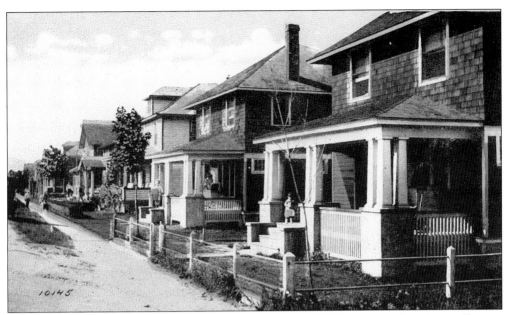

SCENE ON SHELL ROAD, 1920. Colorful postcards bearing artists' renderings depicting small-town life in the neighborhoods of Carneys Point were also published by S. R. Bowen of Penns Grove and were reproduced up until the late 1950s. This street scene shows the permanent well-constructed homes built by DuPont from 1917 to 1919. These were often the homes of supervisors or managers at the DuPont plant.

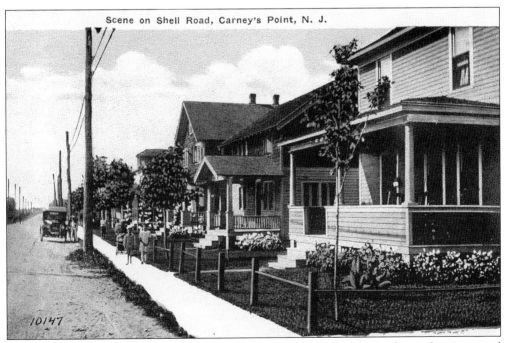

Scene on Shell Road, Carney's Point, N. J.

COLORFUL STREET SCENE ON SHELL ROAD, 1920. These larger homes boasted neat covered porches where one could sit and watch the traffic go by on the Village's main boulevard. It was also more convenient for shopping in the businesses along Shell Road.

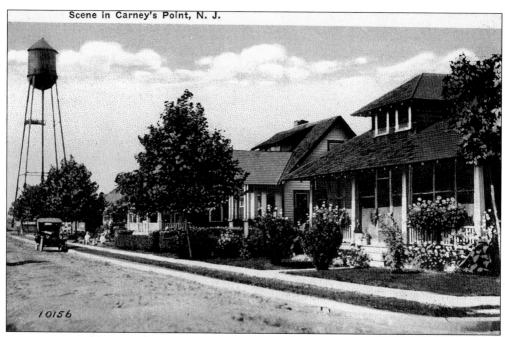

NEAT NEIGHBORHOODS IN THE VILLAGE, 1920. One could work in the yard or just relax on the porch of their very own home after a hard day's work at the DuPont plant.

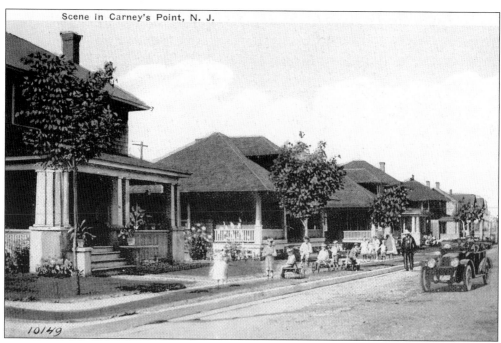

A KID'S LIFE IN THE VILLAGE, 1920. Children could play on their neighborhood blocks, not straying far from their own front door.

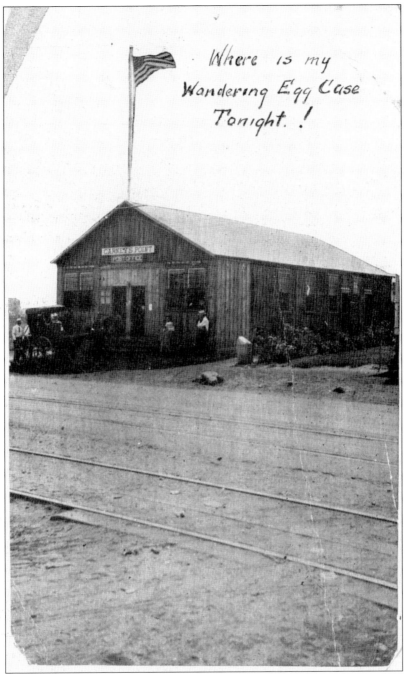

THE POST OFFICE AT CARNEY'S POINT, 1918. A post office was opened early in 1916 in the village on Shell Road. The name, Riverview, which was being used for the village, could not be used because there already was a post office by that name in New Jersey. Therefore, the village became Carney's Point. Extra post office boxes were placed in the YMCA building. An announcement was made that on January 16, 1918, Carney's Point Post Office would become a substation of the Penns Grove Post Office and that the Penns Grove Post Office would start delivering mail to Carney's Point homes.

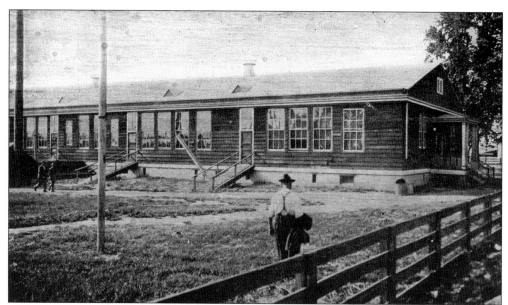

THE GREEN SCHOOL IN THE VILLAGE, 1918. The DuPont Company built a one-story, large school west of Shell Road, opposite Washington Street, for use as a public school. It was ready for use on September 20, 1915. It was known as the Green School or the DuPont School. The school was eventually torn down in 1952, and the land became a parking lot for the Union Presbyterian Church across the street.

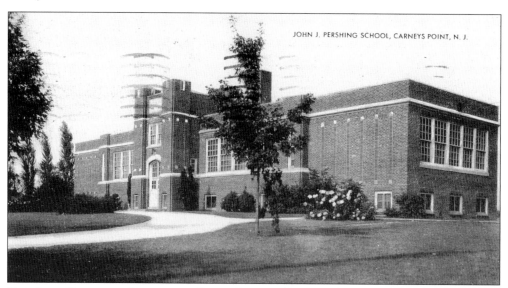

JOHN J. PERSHING SCHOOL, CARNEYS POINT, N. J.

THE JOHN PERSHING SCHOOL ON SHELL ROAD, 1930. Faced with rapid population growth, the Upper Penns Neck School Board built a large, two-story brick school on the site vacated by the original Cove School, also referred to as the Lafayette Academy. This was named Lafayette School. In 1925, the Ruberoid two-story row houses or barracks, some of which had been converted to classrooms, were torn down, making way for another school to be built next to the Lafayette. A large, one-story brick school, the John Pershing School, was then added to Shell Road. The school was named for Gen. John "Black Jack" Pershing, who served as commander of all the Allied armed forces in World War I. He was the first five-star general in the United States.

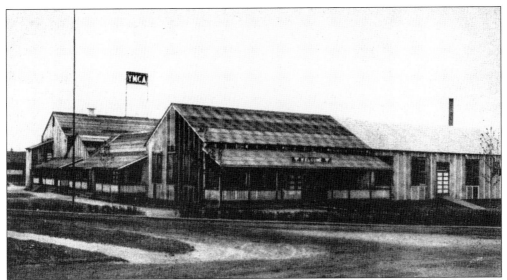

THE YOUNG MEN'S CHRISTIAN ASSOCIATION, 1915. The YMCA was housed in a group of buildings near Walker Avenue. There was a movie theater and a gymnasium. The Village Improvement Society of the YMCA arranged for many activities, such as concerts, boat rides, and carnivals. There was a great interest in baseball, and teams made up of workers from many areas of the DuPont Dye Works and DuPont management competed. The YMCA also operated a nonprofit restaurant. In 1939, a new, larger YMCA was built by DuPont on the west side of Shell Road near the border of Penns Grove and Carneys Point.

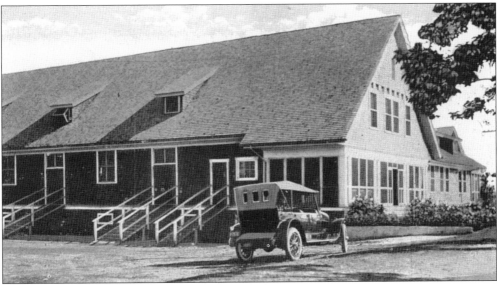

THE FIRST DUPONT CLUBHOUSE, 1920. The DuPont Club was organized on December 30, 1918, with Clayton J. Ziegler, chief chemist at Plant No. 1, as president. The DuPont Company built a large clubhouse near the river and the Ziegler tract. The two-story frame structure had a downstairs auditorium capable of seating 400, bowling alleys, pool tables, a lounge, library, kitchen, and dining room. The auditorium had a stage and was suitable for meetings, dances, shows, and indoor sports. The building was built at a cost of $50,000. A horrific fire destroyed the clubhouse in 1936.

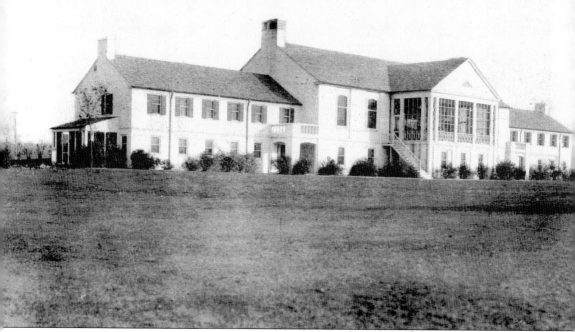

THE NEW DUPONT CLUBHOUSE, 1935. Having lost the first DuPont clubhouse to a fire in 1936, DuPont proceeded with plans for a new clubhouse. The company built a large clubhouse with a golf course, extending from it westward to Shell Road. This splendid new clubhouse, which cost nearly $100,000, was officially opened with a formal dinner and dance on December 11, 1936. Attracted by the new facility, membership increased from 170 in October 1936 to 339 in October of the following year. The club activities through the years ranged from mahjong parties to chamber music recitals, formal balls to clambakes, golf, billiards, card parties, and other recreational and social functions. The club building, with its spacious ballroom, also provided a meeting place for large, civic functions, as well as for DuPont Company organizations. When the clubhouse organization dissolved, the building became home to the Salem Community College, which was established in 1972.

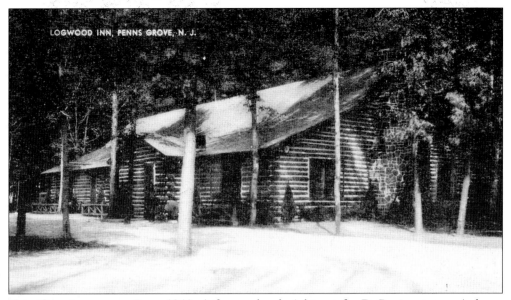

THE OLD LOGWOOD INN, 1940. A famous local nightspot for DuPonters to unwind was the Logwood Inn on Harding Highway, just outside Penns Grove and the Village. Music and dancing could be found at this local hot spot. The old Logwood Inn later became home to Bomba's Restaurant. After the restaurant closed, the structure was renovated and now serves as the Carneys Point Township Municipal Building.

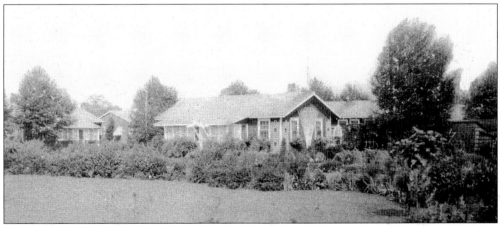

FATHER OF DUNN'S PARK, A. J. DUNN, 1930. Alfred "A. J." Dunn was a chemist employed by the DuPont Company. Originally from Ireland, Dunn made his home in the Village on the corner of Bay and J Streets. A. J. Dunn was well respected and involved in his community. When a need presented itself, he would do everything in his power to fulfill that need. When the need for some type of recreational area was brought to his attention, Dunn made plans. He was responsible for clearing out the areas just off Shell Road, where some of the Ruberoid barracks once stood. In their place, baseball fields and a community park for the people of the Village were created. Well-known for his horticultural activities, under his direction, improvements were made to the park during the late 1930s, with the addition of a lovely water fountain and walkways. Many wonderful trees and blooming plants were also added. The park on Shell Road still has most of those trees planted over 60 years ago and, as a testimonial to him, still bears his name, Dunn's Park.

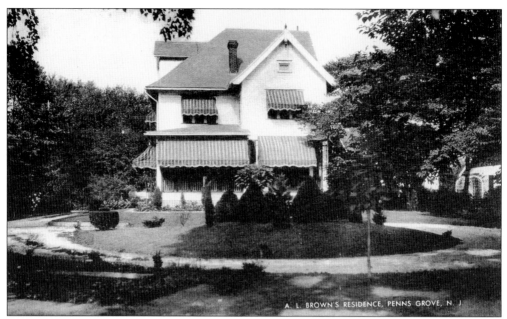

A. I. Brown's Residence in Ziegler Tract, 1930. Hidden away next to the Ziegler tract is the Brown residence. The view is spectacular since the home sits on what was originally the Helm's Cove landing.

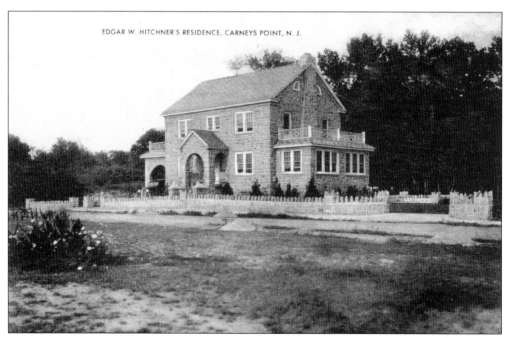

Edgar Hitchner Residence, 1940. A Colonial Revival stone residence, this home was built for DuPont executive Edgar Hitchner in a small development just off of Shell Road.

Ten

Carneys Point and the Powder Works

E. I. DuPont De Nemours-Powder Works at Carney's Point, 1910. Carneys Point Works was founded in 1890 for the purpose of making smokeless powder for the military and sporting powder for commercial use. Smokeless powder is not a powder. It received the name powder because it replaced black powder as the propellant for guns, cannons, etc. On the back of this card addressed to Edward Arper, DuPont Pierce Company, Washington it states, "This is a sample of powder plants in NJ, give my love to your mother, HCP."

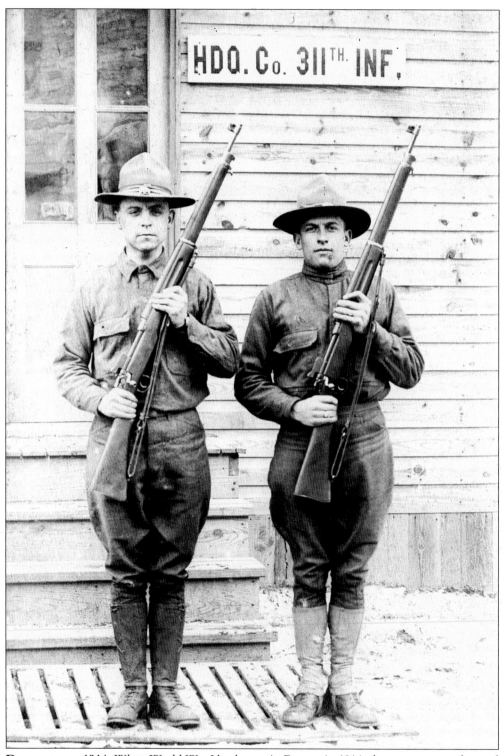

DOUGHBOYS, 1914. When World War I broke out in Europe in 1914, there was a great demand for smokeless powder.

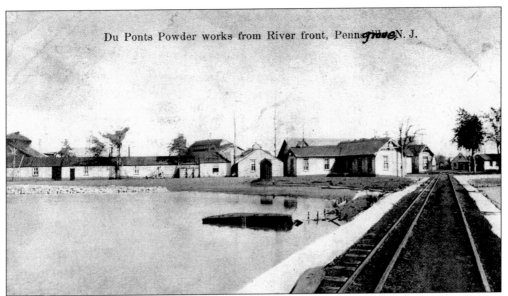

Du Ponts Powder works from River front, Penns*grove*N. J.

DuPont Powder Works from the Riverfront, 1909. England and France sent agents to the United States to find suppliers to meet the demand for smokeless powder at the start of World War I. The DuPont Company offered to meet all of their demands. DuPont purchased almost all of the farmland, from Helm's Cove to the canal at Deepwater, and immediately began enlarging the facilities for the production of smokeless powder and constructing homes for their employees. Men came by the thousands to work at the plant.

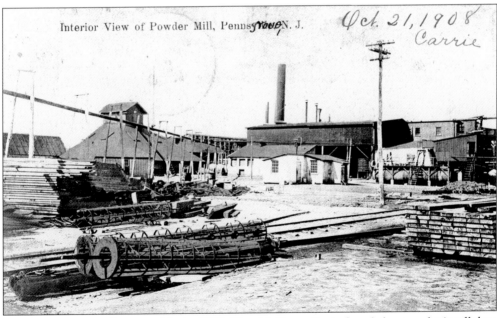

Interior View of Powder Mill, Penns*grove*N. J. *Oct. 21, 1908 Carrie*

Interior View of Powder Mill, 1908. The chief ingredient of smokeless powder is cellulose nitrate, which is made by treating cotton with a mixture of acids until it is fully nitrated. In the summer of 1917, DuPont began hiring women to work in the cutting houses. These women wore khaki bloomer uniforms and were called the Boomer Girls. Between 1890 and 1915, four powder lines were constructed, and by 1979, the entire plant was shut down.

CARNEYS POINT FROM SOUTH PENNS GROVE, 1909. This E. W. Humphreys photo postcard captures a serene view of Carneys Point Plant No. 1 in the background.

BATHING BEACH AT CARNEY'S POINT, 1909. A favorite pastime for folks in the Village, was spending time at the beach on the riverside. Wading in the natural cove off Plant Road was a great way to spend a hot, summer afternoon. At one time, there were change houses along with benches. One could swim, boat, and fish all within the sight of the DuPont Plant No. 1, seen here in the background

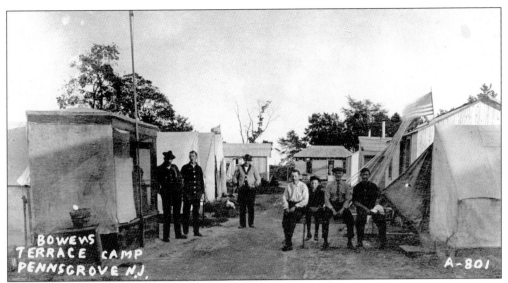

BOWEN'S TERRACE CAMP FOR PLANT ONE WORKERS, 1910. Lack of housing for the sudden influx of workers at the DuPont Plant caused the need to establish tent cities until more permanent housing could be built. Bowen's Terrace camp was one of the emergency housing facilities that they referred to as camps, used during the war boom from 1916 to 1918. Single men, or married men who had come to the area without their families, inhabited these camps. The population in the area in 1900 was 2,118. In 1915, the population increased to 4,412. At the peak of the boom time, the population was 15,000 in Penns Grove and Carneys Point.

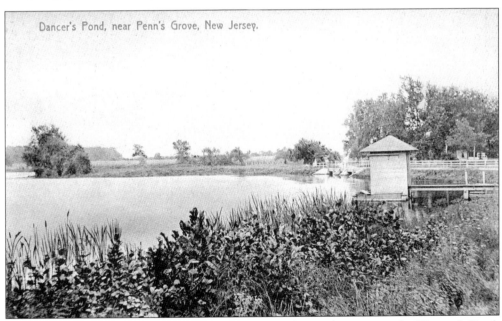

DANCER'S POND, 1910. Seen here is an E. W. Humphreys photo postcard of Dancer's Pond, which was once owned by Thomas Carney Jr. A gristmill was built on the property in 1740 on land deeded to John Wilder by the sons of William Penn. The mill was purchased by Thomas Carney Jr. and John Summerill in 1788. Later the mill passed into the hands of Burden Dancer Sr. and is shown on an 1848 map as B. Dancer's gristmill.

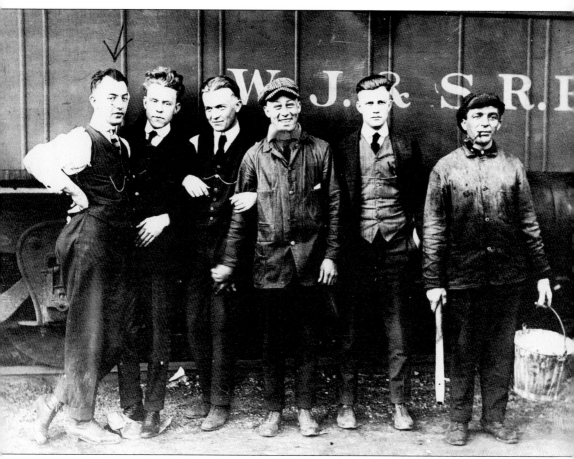

WORKING ON THE RAILROAD FOR DUPONT, 1918. The railroad became important to the growth of Penns Grove and Carneys Point. Passenger service to the DuPont plants was started in 1915. Railroad cars were rented, and a train ran from the Penns Grove Railroad Station to the various plants. The train ran along the river to Plant No. 1 and on through to Deepwater, making three round-trips a day. The railroad was also used to transport products from the DuPont plants. West Jersey and Seashore Railroad was in competition for DuPont business. Shown here are workers of West Jersey and Seashore Railroad. Gearl George Garton (society member Sarah Hyson's daddy) can be seen at the far left.